MASTERPIECES OF
AUSTRALIAN PAINTING

Publisher George Barber
© Bay Books
Published by Bay Books Pty Ltd
61-69 Anzac Parade, Kensington, Sydney, NSW 2033, Australia.
National Library of Australia
Card Number and ISBN 0 85835 804 2
Typeset in Goudy Old Style by InterType, Sydney.
BBR986

Printed in Singapore by Toppan Printing Company.

MASTERPIECES OF
AUSTRALIAN PAINTING

MARTIN TERRY

BAY BOOKS

CONTENTS

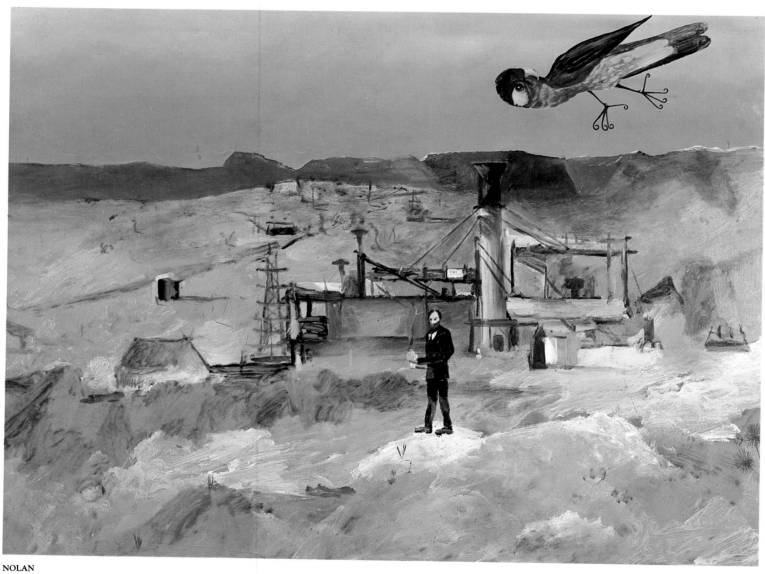

Pretty Polly Mine, 1948
Ripolin on hardboard

FROM SETTLEMENT TO THE 1980s: AN INTRODUCTION TO AUSTRALIAN ART

Unlike the artists and paintings of Europe which are usually grouped by movements or schools such as baroque, renaissance, impressionism and surrealism, the history of Australian art is best understood by looking at the works of many individual artists.

Over the past 200 years, Australia, her people and culture have been portrayed in a number of mediums: pencil, ink, crayon, charcoal, watercolour and oil for all sorts of reasons. Some artists, such as those who accompanied Cook on his voyage of discovery, painted our flora and fauna purely for botanical and zoological reference. Other skilled amateurs in the early days of settlement depicted daily life in the colony for historical records, while others painted their new surroundings as a means of expressing their own personal and emotional needs.

It is therefore, true to say that the earliest art in Australia was an attempt to document and understand an unknown, very different land at the very end of the earth. The first painters were a motley group of military and naval men, convicts, free settlers and a few professional artists whose work was a representation of life in small, fledgling settlements, early records of our unique flora and fauna and sketches of the mysterious Aboriginal inhabitants.

First, significant oil painting

It was a convict, Thomas Watling who executed Australia's first oil painting: *A Direct North General View of Sydney Cove* (1794). Watling, like many other early artists, could not come to grips with the harsh, Australian landscape. He painted in the picturesque manner of the romantic painters of the eighteenth century and depicted Sydney in a way familiar to Europeans.

In his first oil, there is very little to suggest Australia. In the foreground, two smartly-dressed Europeans are engaged in idle conversation. The Aboriginals are almost totally hidden and the trees framing the picture barely resemble eucalypts.

Thomas Watling was transported for forging bank notes so it is perhaps appropriate that the first significant Australian landscape painting strikes a rather false note.

Early watercolours sent to England

One particular mission for the early Australian artist was to keep those at home in England informed and entertained of developments in the colony. There were very few early oil paintings. Far more typical were watercolours and drawings which often took the place of picture postcards. These illustrations were later made into prints for use in British publications created to satisfy readers who were interested in exotic, far-away lands.

One of the best of these watercolourists was John Lewin, a landscape artist and scientific illustrator. His engravings of insects were the first published in the colony and he is also credited with starting the first art school in Sydney in 1812. Lewin's painting *Gymea Lily* was widely acclaimed.

The artist Joseph Lycett, like Watling, was convicted of forgery and sent to the colony in 1814. Lycett made many watercolours of the early mansions built by free settlers and members of the Rum Corps. When pardoned by Governor Macquarie, Lycett undertook an ambitious work: a visual survey of New South Wales and Van Dieman's Land. A book of his work was published in London in 1824 and common to many of the views illustrated is a foreground of plant life, intrepid bushmen, hard-working shepherds and picturesque Aboriginals.

First important landscape artist

Famous in England as a painter and teacher, John Glover emigrated to Tasmania in 1831 where he took up a government grant of wheat-producing land in the northeast of the state.

It was probably fortunate that Glover settled in Tasmania, an environment that has always been likened to England. In his native country, Glover had specialised in paintings of the Lakes District and in Tasmania he could use his special empathy with pastoral life to full advantage. Unlike other landscape artists of early Australia, Glover was able to portray the settler living harmoniously within the landscape.

Glover wrote of Australia in 1830 that he expected to find a 'new beautiful world — new landscapes, new trees, new flowers, new animals, birds . . .' and he struggled to capture this environment in paint.

In spite of his proclaimed enthusiasm for things new, Glover revealed his homesickness in a painting *Glover's House and Garden* (c.1840) which shows his property to be as carefully cultivated as any provincial English garden plot. Only in the background do native plants appear against a blue, wide-open Australian sky.

Glover's Tasmanian successor in the depiction of landscapes was John Skinner Prout. While Glover's paintings reflect the artist's calm acceptance of his new surroundings, Prout's paintings highlight a fascination with the Australian landscape.

In Hobart in 1845 Prout arranged one of the first exhibitions of pictures in the colony and due to its success a colonial picture gallery was established. His *Valley of Ferns, Hobart* was really designed for an English audience who readily accepted ferns, rather than eucalypts as representing botanical Australia.

Early portrait painters

Portraiture was also of interest to our early artists who were always eager to gain a worthwhile commission. One of the most highly regarded portrait painters during the colonial period was the convict Thomas Griffiths Wainewright.

Wainewright who exhibited at the Royal Academy in 1821 and 1825 was a noted painter of women. He often executed portraits of the wives of colonial officials in their own homes while the artist himself was under guard. Wainewright's masterpiece is a portrait of the Cutmear twins, Jane and Lucy. In this painting the faces and hair of the twins are emphasised. As a portrait it is remarkable in that it successfully combines poised calm and steely firmness with the exquisite vulnerability of its young sitters.

The artist of colonial Sydney

A world traveller and landscape artist who once sailed with Charles Darwin in the *Beagle*, Conrad Martens settled in Sydney in 1835 and set about accurately recording colonial life in the town and the harbour.

Martens settled in 'The Rocks' area and built up a considerable reputation as a landscape painter; his watercolours were often taken back to England as souvenirs. Although he tried to paint an honest picture of colonial Sydney, it was an image seen through European eyes. In his watercolour *Looking East over Circular Quay from Miller's Point* (c.1838) we might be looking at an English seaport.

Martens is aware however, of the futility of trying to recreate home too enthusiastically. His masterpiece, *View of Sydney from Neutral Bay* (c.1857) is not a detailed work but more general and interpretative. In this painting, his clouds create a truly impressive, inspiring effect, reminiscent of the English artist, Turner.

Art of the goldfields

The discovery of alluvial gold in the early 1850s convulsed Australia. Men and their families left settlements to trek hundreds of kilometres to the latest strike in order to make their fortune. Amongst the throng in search of wealth were artists. One of them, Samuel Thomas (S.T.) Gill has left us with the most comprehensive picture of what life was like on the goldfields.

Born in England, Gill's career began in Adelaide when he painted the watercolour *Sturt's Overland Expedition leaving Adelaide* (1844). This painting portrays the humour and simplicity which made Gill famous. In the background of the painting is the pomp and cavalcade of the Sturt expedition members while in the foreground is a happy confusion of locals, children, dogs, bottles and barrels.

Moving to the Victorian goldfields in 1851, Gill was unsuccessful as a digger but was perhaps the most successful graphic chronicler of the gold rush and bushwhacking life of those times. Gill had an obvious preference for the rowdy and noisy aspect of the diggings; *McLarens Boxing Saloon* is a typical example.

Gill's first sketches of the diggings in 1852 were entitled *A Series of Sketches of the Victorian Gold Diggings as They Are*. Although drawn to more jovial scenes, Gill was not a blinkered optimist; in his work he included unlucky diggers, the thwarted explorer and those down on their luck.

One of the first artists to arrive at the goldfields was an Englishman, William Strutt. In spite of a handicap of poor eyesight, Strutt worked as a successful illustrator and was a foundation member of the Victorian Society of Fine Arts. One of his best known pictures was *Black Thursday, 6 February 1851*, the scene of a disastrous bushfire which Strutt painted later in London from sketches done on the spot. Another of his epic works, *The Departure of the Burke and Wills Expedition 1861*, demonstrates his fine skill as a draughtsman.

Perhaps the most impressive of the artist emigrants was the Australian-trained German, Eugen von Guerard who became the first master of the painting school at the National Gallery of Victoria. While Martens was largely a New South Welshman, von Guerard was a Victorian. His paintings were often criticised for being far too detailed but his *Waterfall, Strath Creek* shows that his skill and temperament went far beyond that of a topographical cataloguer.

The composition of the rocks, trees and flowers may be organised but the viewer is drawn towards the blue of the sky as we are towards the dome of a church. This painting is a celebration of God's work; it is a painting of a natural chapel not a natural history museum.

Nineteenth century artists were fascinated by our landscape, rarely overwhelmed by it. Von Guerard accompanied an expedition to Mount Kosciusko where he accurately drew the Alps without losing the detail. The result is a thrilling, awe-inspiring vision.

Early French influence

Louis Buvelot arrived in Melbourne in 1865 and although European-trained like von Guerard, he approached his subjects with far less formality and detail. His work, also of Victoria, is filled with gentle respect for the untidy aspects of landscape, the weathered timber of an old fence, the tangled roots of a fallen riverside gum. His *Winter Morning, near Heidelberg* (c.1869) is a fine example of work done in the open air. Buvelot, often called the 'grandfather' of Australian landscape painting, always gave strict attention to the accuracy of what he saw and placed supreme importance on light and local colour.

Buvelot brought to Australia two influences; that of French artists such as Theodore Rousseau and Charles Daubigny who painted out of doors and were interested in small glimpses of nature, and Dutch painting such as those of Jacob von Ruisdael with their interest in flatness, ideal for interpreting Victoria's Western District and well illustrated in *The Woolshed, near Camperdown*.

At this time, an outstanding personality in Sydney's art world was Julian Ashton who was born in England and arrived in Australia in 1878. Ashton was a painter, illustrator, teacher and writer and founder of the Sydney Art School which became famous for many

generations of art students. Artists George Lambert and Thea Proctor were among his students which demonstrates that Ashton knew when not to intrude upon talent.

Ashton himself executed a number of oil paintings but his watercolour, *A Solitary Ramble* (1886) is generally thought to be his masterpiece. For its qualities of sunshine, light falling on fabric, a very ordinary event treated in a relaxed way and its attractive fresh air feeling, this painting anticipates the work later in the decade of Tom Roberts, Charles Conder, Arthur Streeton and Fred McCubbin.

Ashton fought hard for Australian art and artists all his life. He organised the first exhibition of Australian art to be sent overseas and as a trustee of the Art Gallery of New South Wales bought the first Streeton painting ever sold to a public gallery.

Birth of Australian impressionism

Australia approached its centenary in 1888 in a mood of increasing confidence. It was no longer a gaol or a sheep station, gold had seen to that. It no longer felt particularly British as Federation was only 12 years away.

This mood of spirited nationalism was to find an equivalent in art in the work of four impressionist artists. In their work the landscape was no longer merely reminiscent of England or France as seen by John Glover or Louis Buvelot. Nor is it depicted with a view to accurate description.

Tom Roberts' painting *Holiday Sketch at Coogee of 1888* points towards the new direction of Australian art. Sunshine and light are prominent as well as the creamy crust of the breaking waves and the decorative curves of the trees. Because the light in Sydney is affected by its moisture-laden humidity, figures are just suggested, as if in a heat-haze.

It took nearly a century for Australian artists to acknowledge the island aspect of the continent, and to depict, not with wariness, but affection the beaches of Melbourne and Sydney.

In 1889 an exhibition of '9 × 5 Impressions' was held in Melbourne. These little paintings on cigar box lids were rapidly-executed suggestions of landscapes. Arthur Streeton's *The Clearing, Glenbrook* is characteristic of this approach.

Australia even by the 1880s was largely an urban country; most people lived on its coastal rim and the Australian impressionists acknowledged this with scenes of busy streets, train stations and crowded wharves. These scenes however exist in every city. What was needed was something that seemed particularly Australian and this was the Australian bush and the simple hard life of outback Australians.

About this time, both Arthur Streeton and Charles Conder were concerned with techniques for handling sunshine and light. Streeton saw sunlight in mystical, nationalist terms (he wrote of the West as 'a flood of deep gold near the gates of Paradise') and Conder had an invalid's love of warming heat (he had been sent to Australia because of failing health). Their shared concern for a looser painting technique is seen in Streeton's *The Selector's Hut (Whelan on the Log)* and Conder's *Under a Southern Sun*. Both however make a decorative feature of the eucalypt and with their strong, right-angled verticals and horizontals there is a real sense of the sky and land infinitely extending beyond the boundaries of the paintings.

The famous Heidelberg School

When Tom Roberts and Frederick McCubbin began painting in the open air at suburban Heidelberg and Box Hill outside Melbourne they were later joined by Charles Conder and Arthur Streeton. These four artists formed the nucleus of a group which were to produce the most outstanding examples of Australian impressionist art.

Although Conder shared with the others the themes of orchards, farmyards and seashores, he arrived at his own style influenced by Whistler and Japanese prints. He was an artist of spring and blossom. In *Springtime, Richmond* (1888) these qualities are delightfully expressed.

Fred McCubbin, the Melbourne-born artist was a more stolid personality. His early works are glimpses of the family bakery where he worked but he too was to develop a love of

the bush. He used the bush as a backdrop for paintings about pioneering life. His *North Wind* is one of the most impressive images of the hardships of country life and *The Lost Child* (1886) is considered one of his most famous works.

Roberts and Streeton also depicted the role of the worker. Roberts' *The Golden Fleece* is a heroic celebration of wool and those who help produce it. Streeton's *Fire's On, Lapstone Tunnel*, although inspired by a worker who had died in an accident becomes a majestic landscape of the Blue Mountains region.

The interest of Australian artists in sunshine was relatively short-lived. Roberts, Streeton and Conder all soon left for Europe and when Roberts and Streeton returned their work was less lively. McCubbin remained in Melbourne, treating the Yarra Valley in autumn, russet tones.

Another associate of the Heidelberg school of painters was David Davies who was born at Ballarat. Like the other impressionists Davies was also predisposed to painting from nature. His *Golden Summer* painted in 1888 captures the bleached tones of the eucalypts and the qualities of cleared land. In his paintings of the 1890s such as *Moonrise, Templestowe* the light is lowering and moody, the foliage and grass generalised. We might be already in the Cornwall to which Davies moved a few years later.

Another Australian-born artist of this period was W.C. Piguenit. He also preferred the blurred edges of a landscape, mist softening a mountain peak and mangroves hiding a river bank. His most impressive painting *Flood in the Darling* (1890) obscures the boundaries between water, foliage and sky. His sunshine is not harsh and direct but watery and diffuse.

The exodus to Europe

Despite a new feeling of nationalism at the achievement of Federation in 1901, most Australian artists felt that the exciting artistic possibilities were still in Europe. In Paris and London, Australians became familiar with the paintings of the Old Masters and contemporary European artists.

Hugh Ramsay was a promising young artist when he left Melbourne in 1900 to travel abroad. In Europe he was inspired by the Old Masters such as Titian and Velazquez and modern artists like Whistler. As a result his paintings became rich, dark and tonal. In *The Sisters* the sitters are dramatically contrasted with the background to achieve an effect of startling liveliness. Before his death from tuberculosis, Ramsay painted a number of portraits which show great skill.

Artist George Lambert also travelled to Europe on the same ship as Hugh Ramsay after having won the first New South Wales Travelling Art Scholarship. Julian Ashton's favourite pupil, Lambert's work suggested an almost direct contact with the Old Masters. He remained in England for about 20 years before returning to Australia to concentrate on portraiture, both painted and drawn. As a student, Lambert looked closely at Gainsborough's portraits and there is an eighteenth century quality in his early masterpiece, a portrait of fellow artist and close friend Thea Proctor.

With the possible exception of a number of Lambert family groups, the most pictorially ambitious of Australia's expatriate Edwardians was Rupert Bunny. Fantasy and reality both co-existed with Bunny; he could combine classical myths with portraiture and beautifully observed landscapes.

One of his most impressive paintings, executed in the first decade of the century is *A Summer Morning* where a somewhat ordinary event has been transformed into an image of celebratory leisure.

Bunny always strove for a full-throated effect while others were happy with a more modest approach. The Melbourne-born artist E. Phillips Fox and his wife Ethel Carrick although often associated with Bunny were still most influenced by impressionism as was the Sydney artist John Russel who was a close friend of Tom Roberts. Fox's works *The Arbour* and *The Ferry* (1911) illustrate vividly his fondness for colour and light.

Max Meldrum was another Melbourne artist who lived in Paris and returned to Australia just before World War I. On his return, Meldrum became an influential teacher and advocated the theory that painting is a science based on the 'invariable truths of depictive

art'. In spite of his hardened formulas, Meldrum produced sensitive landscapes such as *Picherit's Farm* in 1910.

Another student of the Julian Ashton Art School, Goulburn-born artist Sid Long also studied overseas and exhibited at the Royal Academy. Long was influenced by the fashionable Art-Nouveau style and on his return to Australia, transformed the gum into a curling decoration and the bush became a setting for a myth.

The beginnings of modern art

When artists returned to Australia before World War I, they brought with them many new ideas of modern art that were emerging in Europe. However, even some decades after its impact in Europe, impressionism was still influencing Sydney artists.

Impressionists such as Seurat and Claude Monet used rapidly-applied dabs or strokes of colour to try and create the effect of ever-altering light. Roland Wakelin who arrived in Sydney from New Zealand in 1912 openly acknowledged this technique in his *Fruit Seller, Farm Cove*.

Just as Tom Roberts brought Streeton and Conder in touch with impressionism through sketches he brought out from London, Roland Wakelin, Roy de Maistre and Grace Cossington Smith, all students at the time were introduced to modern art by Nora Simpson who brought out reproductions of Cezanne's work in 1913.

Grace Cossington Smith who studied in London was interested in Gauguin and Van Gogh and their contemporary followers. Her 1915 oil *The Sock Knitter* is a startling work. Instead of being a quiet portrait, the interest is centred on the clashing colours and the peculiar shapes of the clothes hanging on a peg, the large ball of wool and the sack-like dress. The modern art movement in Sydney was promoted by Roland Wakelin, Grace Cossington Smith, George Lambert, Elioth Gruner, Margaret Preston, Roy de Maistre and Thea Proctor.

Perhaps the most enthusiastic supporter of the new trend was Margaret Preston. Her oil *Implement Blue* (1927) with its limited number of colours and exquisitely poised composition proclaims the machine age. In a curious way Preston anticipated by forty years, experiments by later painters in hard-edge colour. She was a strident, often unthinking exponent of things Australian and in *Western Australian Gumblossoms* transforms her subject into a powerful obelisk.

The modern movement which began later in Melbourne was started by William Frater, Arnold Shore and George Bell. Other artists began to find the source of their images not in reality, but in the flickering impressions remembered from dreams. James Gleeson is Australia's most consistent, thoughtful surrealist. His corroded figures are placed in that most Australian of landscapes, the beach.

Adelaide-born artist Jeffrey Smart was also influenced by surrealism, particularly the empty, haunting architecture of the Italian painter, Giorgio de Chirico. Smart's earlier paintings, such as *Cape Dombey* show this preoccupation, combined with a textural paint surface. His later works show an alien world in his sleek, smooth freeways.

Landscapes of a harsh interior

Often thought of as father of the gum tree school, Hans Heysen mastered the painting of massive gum trees and the light and colours of pale trunks and peeling bark. Watercolour was his best medium. From his home in Hahndorf outside Adelaide he travelled to the Flinders Ranges in central Australia and painted landscapes of the interior such as *The Three Sisters of Aroona* (1927).

Popular landscape artist Elioth Gruner travelled widely through the richly fertile sheep and dairy country of New South Wales. His works, such as *Spring at Bathurst* are bathed in a flattering light for he favoured the gentler atmospheric times of day; milking time at dawn or the falling light of dusk.

The city for some artists, an exciting world of cocktail shakers and sports cars, was also interpreted in a conservative, restrained way. Swiss-born Sali Herman, best known for his paintings of street scenes and old buildings, invested Sydney with a quality of Old Europe.

An able, atmospheric water colourist, Donald Friend was one of the leading artists of the Sydney group in the 1940s. He later became better known for his visions of Bali where he lived for many years. Also prominent in the 1930s and 1940s was Brisbane-born Lloyd Rees whose work fitted in with the romantic school dominant after the war. In the 1930s Rees executed an astonishing group of drawings, greatly detailed studies of Sydney's lower North Shore, which in their cold, wintry way, associated Sydney with the age-old landscape of Italy. From the 1940s Rees' ordered approach became more released. Like a conductor he could subtly orchestrate the movement of a painting. In *The Harbour from McMahon's Point* for example we unavoidably follow the rhythm of cove and headland.

One of Australia's most outstanding portraitists, William Dobell added new dimensions to the stature of Australian paintings with his works during the 1940s and 1950s. Unwittingly Dobell was at the centre of an art controversy and court case when he won the Archibald Prize in 1943 for his portrait of *Joshua Smith*.

The artist's reputation and talent were vindicated when he again won the Archibald Prize with a baroque-styled painting of *Margaret Olley* and in the same year,1948, won the Wynne Prize for landscapes with *Storm Approaching Wangi*. Another outstanding work was *The Strapper* (1941).

In Melbourne in the 1940s, a darker mood prevailed with younger artists. Arthur Boyd in his early works openly acknowledged the influence of European artists such as the Flemish artist Pieter Breughel. *Mining Town* is filled with a happy sense of humanity but in *The Mockers*, the crowd turns nasty. A conflict has often been present in Boyd's paintings; a love of landscape contrasting with horrible deeds. Even a painting as innocently presented as *Irrigation Lake, Wimmera* with its circling crows and creepy cart has an air of imminent unpleasantness.

Albert Tucker who is often seen as a pioneer of surrealist and symbolist painting was also painting in Melbourne at this time and is seen as a contemporary of Boyd. Tucker's commanding cycle of paintings, *Images of Modern Evil* was based on the raw edge of life in Melbourne during World War II and warned of the horrors of hell. They are described as the most moral paintings in Australian art.

Another young artist John Perceval, also displayed a bleak view of people during this period with his *Boy with Cat*. However his later works were to be more joyous.

Joy Hester who was married for a time to Albert Tucker concentrated on an intensely personal language of fear and desire in her impressive watercolours.

The post-war moderns

Melbourne never held for Sidney Nolan the fears of Tucker or Boyd. His precocious painting, *Bathers* (1945) is an evocation of water and sunshine not seen since the time of the Australian impressionists. *Bathers* is not only a daring composition, but there is just enough suggestion of beach towel and swimmer.

A similar directness is present in Nolan's famous Kelly series. The helmet is a marvellous invention, somewhat sinister but it is essentially as neutral as a letterbox. It perfectly suits Nolan's approach which is to tell the story, episode by episode, clearly and without commitment. Nolan's only opinion is that the story itself is sufficiently interesting to warrant the large-scale attention of an artist. His *Death of Constable Scanlon* demonstrates this effectively. In this, there is a direct link to the bushranging subjects of Tom Roberts who had a similar passive viewpoint.

Nolan has always been challenged by the harsh parts of the world: Antarctica, Africa and outback Australia. His *Pretty Polly Mine* (1948) is once again a story; a mine manager who fed parrots. The story is set in a landscape so briefly described and yet so richly suggestive of the outback. Nolan's interest in the arid parts of Australia culminated in a number of paintings of inland Australia. Like Heysen, he sees the *Durack Ranges* (1950) as awe-inspiring. The difference now being that Heysen with sketchbook and easel tramped to the site and experienced its grandeur from a camp site at the foothills. Nolan flew over the ranges so his works seem more descriptive, less involved with the subject.

Another artist concerned with the myth of the outback was Russell Drysdale. Unlike Nolan, he doesn't see it in heroic terms, perhaps because he grew up on a country property. Drysdale strives for the ordinary and everyday, but with an edge. In his early paintings of the 1940s, farmers read a newspaper, go to the pictures, or feed the station's scrawny dogs. Drysdale gives us the most eccentric idea of a gumtree for he realised that the eucalypt has been painted so many times, it had lost its expressive qualities. Drysdale's gums are sticks imploring for rain.

These images of an alien world culminate for Drysdale in a series of townscapes of the old gold-mining villages near Bathurst. The towns are eerily deserted, the people have vanished, leaving behind the dogs or a couple of children playing cricket. A number of Drysdale's paintings are more flagrantly surrealist, with corrugated iron being transformed into fantastic shapes such as in *Emus in a Landscape* (1950).

Few artists in the 1950s, except perhaps for Arthur Boyd, could be bothered thinking about the Aboriginal people and their dispossession by white settlement of the interior. Drysdale, however, concerned himself with this problem in a large number of his paintings.

The sentiments expressed in these works perhaps now seem a little patronising but in portraying the Aborigines favourably he was far in advance of many of his contemporaries. His *Station Blacks* (1953) shows a proud family group.

Few artists were prepared to examine the tensions and pleasures of life in Australia during the 1950s and 1960s. Ian Fairweather could be amused by something as Australian as a *Trotting Race* (1956) but he turned increasingly towards a deeply religious viewpoint infused with an interest in Asia, the first Australian artist to look towards the North rather than Europe as a source of spiritual and creative inspiration. Fairweather produced many of his major works like *Monastery* (1961) and *Turtle and Temple Gong* (1965) while living on Bribie Island, Queensland.

Optimism and abstraction of contemporary art

The 1960s and 1970s were more optimistic decades in Australia. Economically the country was affluent and this boom was reflected in the art world where paintings demonstrated a new adventurous liveliness.

John Coburn's paintings and tapestries are bright, decorative hymns. His early paintings were wiry passions and crucifixions, inspired by contemporary French painters, and by the rebuilding of Coventry Cathedral which proclaimed the validity of Christianity. Later Coburn realised that inspiration could come just as easily through more purified shapes and vibrant colour.

Melbourne artist Leonard French holds a unique place in Australian art. A major source of his inspiration was Christian Byzantine art and the religious experience. His works, rich in symbolism, are reminders of stained glass windows and illuminated manuscripts.

Godfrey Miller who had studied architecture evolved a style which has been described as a classic fragmentation of forms and colours. He obsessively examined the nude and landscapes, largely in architectural terms, seeking to understand their fundamental structure.

Robert Dickerson and Charles Blackman both saw the city as sources of fear and alienation. Dickerson pares his images to the bone; nothing unnecessary is present in his images of an abstracted reality. Blackman's works show the psychological undercurrents of life transmitted to the artist through his immediate environment.

In this age of superb photography, the portrait painting still has an important role to play. Austrian-born Judy Cassab won the Archibald Prize in 1967 for her study of the artist *Margo Lewers*, a painting of uncompromising directness where expression, costume and landscape all merge to form a sense of the character of the sitter.

John Brack's work has been greatly concerned with two themes; the traditional artists' examination of the nude, and a series of paintings that portrayed Melbourne suburbia. He is interested in the suburban spectator sports, usually experienced through television, ballroom dancing and ice-skating have been two particular Brack favourites.

All of Brack's feelings about this way of life came together in his best portrait of the 1960s, Barry Humphries in the character of Edna Everage which like his works of skating and dancing is an image of an illusion.

Just as it has been since the earliest days of settlement, Australian artists in the 1960s and 1970s were largely concerned with the landscape. John Olsen has always seen it playfully and lyrically. Inspired by European and American abstract expressionist paintings he saw in the late 1950s, Olsen's pictures on returning to Australia, were filled with vigorous, bold gesturings that reflected his feelings about the energy and vitality of Australia. These feelings are evident in *Journey into the You Beaut Country*.

Olsen's work has become progressively lighter in colour and mood. His watercolours of the Life of Lake Eyre and Central Australia are like microscopic slides, all cellular squiggles and squirmings.

Contemporary artist Brett Whiteley has also been interested in the curves and loops of abstract expressionism. His earliest landscapes, suggestive of rock forms, are ochre, desert colours. These colours have become richer as his notion of landscape has altered to a point where life on the harbour is suggested by the most minimal means such as in *Big Orange Sunset* (1974).

Self-portraits have also been a continuing interest with Whiteley. His intense work and Archibald Prize winner, *Self Portrait in the Studio* (1976) is a summary of his interests; the landscape, harbour, nude sculpture, and the art of the Orient, all held together by the richest tones of blue.

However, the most thorough investigation of the landscape during this time was made by Fred Williams. Living in England in the early 1950s, his interests centred upon the life of the music hall and portraiture such as *Cricketer* (1955) but on his return to Australia Williams quickly became interested in landscape, expressing the Australian bush with a hitherto unseen economy.

With suggestions of twig-like trees and a love of warm orange, pinks, browns and yellows, these paintings consciously evoke the landscapes of the Australian impressionists. The best of these works, including *Upwey* (1965) contain just the right amount of trees, rocks and cleared land.

Williams could portray the landscape with just the merest suggestion of forms; he almost seems to have dared himself to leave out as much as possible. These paintings such as *Landscape* (1969) seem random but each element is painfully considered and carefully placed.

Williams executed many gouaches, an opaque watercolour that is easily handled but gives the suggestion of oil paint. Of these, probably the most ravishing are a series of Weipa landscapes which, seen from the air, read as geological surveys of this ore-rich region.

This summary and overview can only highlight some of the important achievements in Australian art and suggest its range and diversity. Seen over two hundred years, Australian painting is essentially a story of recording, confronting and accepting the landscape. In doing this, art reflects the life and times of Australia itself and the hopes and dreams of its people.

MARTIN TERRY
Assistant Curator,
Prints and Drawings,
Art Gallery of New South Wales

THOMAS WATLING

b. Scotland 1762; arr. Australia 1792; date of death unknown

Thomas Watling was convicted of forging guinea notes and was transported from the Scottish border town of Dumfries to Sydney in 1791. He is believed to be the first professional artist to work in Australia and his accurate drawings of the natural flora and fauna of the Australian bush were a valuable contribution to the records of the time.

Watling was very much a product of the late eighteenth century Romantic school of painting. He looked for picturesque subjects and depicted them in the classical style. His oil painting of *Sydney Cove* is thought to be the first recorded view of Sydney. The manner in which the well-lit central scene is wreathed by dark trees is typical of the Romantic style. However, we learn from letters written to his aunt that he was in fact rather disappointed with the lack of so-called 'picturesque' subjects to be found in his land of exile: 'Bold rising hills, or azure distances would be a kind of phenomena. The principal traits of the country are extensive woods, spread over a little-varied plain'. Other European artists of the time also complained about the absence of historic ruins and autumnal tints.

Watling nicknamed himself 'The Principal Limner of New South Wales' and had plans for an illustrated book of mezzotints, acquatints and watercolours describing the nature of the colony. The project never materialized as Watling received a conditional pardon and was released in 1796.

On only two more occasions did Thomas Watling appear again. From 1801–1803 he was reported to be working as a miniature artist in Calcutta and then in Britain he came to light again forging banknotes, this time five pound ones!

The date of his death is unknown.

A Direct North General View of Sydney Cove, 1794
Oil on canvas

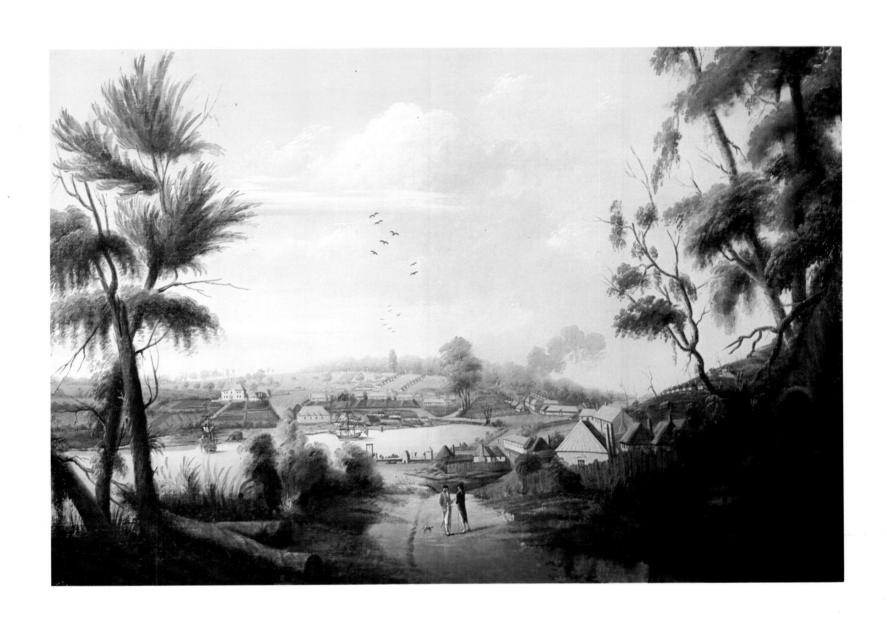

JOHN GLOVER

b. England 1767; d. nr. Launceston 1849

John Glover was born in Leicestershire, England in 1767 and was practically self-taught as an artist. He became fascinated by romantic landscape painting, particularly that of Claude Lorraine and Gaspard Poussin. He worked prolifically as a water colourist and developed a sensitive eye for detail and composition.

When Glover left his native land, at the age of 63, he was a man of considerable means. He settled his family on a farm on the Nile River, near Launceston in Tasmania. The government allocated him a parcel of land and he added to it over the years. Here he contentedly applied himself to painting the new landscape with its creeks and gum trees. He was among the first colonial artists to depict the Australian bush. His paintings have an air of Utopian, pastoral peace and his scenes are always full of warm, clear light. His early influence from the seventeenth century romantic painters remained with him all his life and on occasions he received criticism for his representation of Van Diemen's Land — some said it was too realistic, others that it was not realistic enough.

Glover kept painting in Tasmania until his death in 1849.

Glover's House and Garden, c. 1840
Oil on canvas

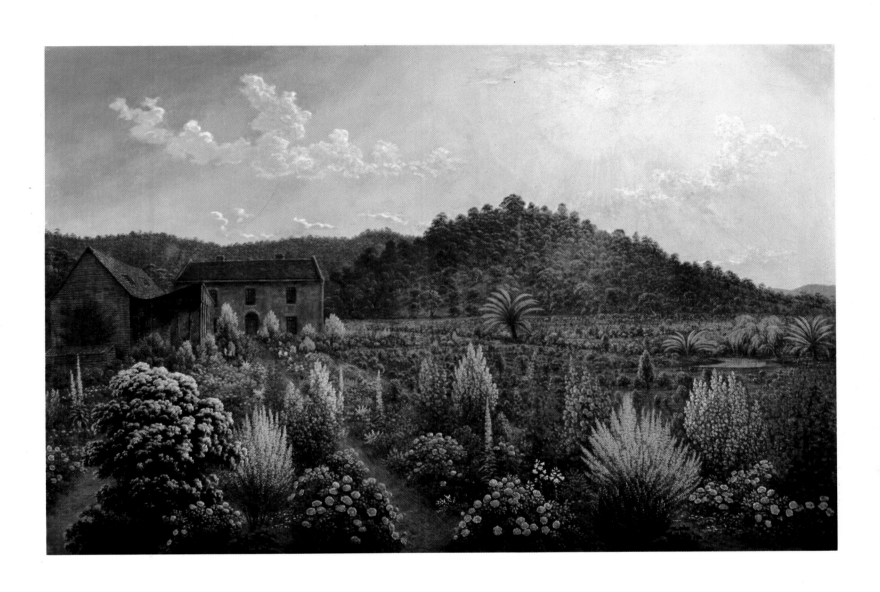

Patterdale Farm, c. 1840
Oil on canvas

JOHN LEWIN

b. England c. 1769; d. 1819

John William Lewin came to Australia with the hope of earning a living as a professional artist but through no fault of his own a series of misfortunes befell him. First he missed the ship on which his wife was already boarded. She was forced to make the journey alone while he caught another from Cork, which was to be delayed for several months by the outbreak of the Irish Rebellion. When he finally arrived in Sydney he found his wife involved in a court case which was providing all the scandal the small free-settler community could digest. As he settled down he established a home in Parramatta and decided to accompany several expeditions around the coast and up the rivers of New South Wales and Victoria, all the while collecting and drawing the native birds, plants and insects. On one voyage he was shipwrecked in Tahiti in the midst of a bloody civil war. This adventure inclined him to a more settled life in the colony. He now began to devote himself to the painstaking delineation of native flora and fauna.

So newly-formed was the colony at this time that Lewin found virtually no market for his work. He had two illustrated books published in London — one on the lepidopterous insects of New South Wales and another on native birds. The bird books intended for the colony never arrived. The reason remains unknown but it is believed that a fire in the warehouse of the printers destroyed them. Seven, intended for the English market, have survived to this day. Financial considerations compelled the Lewins to move to Sydney.

When Lachlan Macquarie arrived in 1809 he was quick to recognize Lewin's talent and from there on Lewin's prospects improved. In 1815 he accompanied a large party, including the Governor and his wife, on an expedition through the Blue Mountains to inspect the new town of Bathurst. On this trip he painted twenty-five watercolours of the countryside. Although they lack technical skill and do not abide by any of the traditional rules of the academies it is generally considered that Lewin captured the spirit and atmosphere of the bush in a way that none of the later Romantic painters of the century were ever able to do. Fifteen of these watercolours are to be found in the Mitchell Library in Sydney.

Lewin remained in Australia for 20 years until his death in 1819.

The Gigantic Lily of New South Wales, 1810
Watercolour

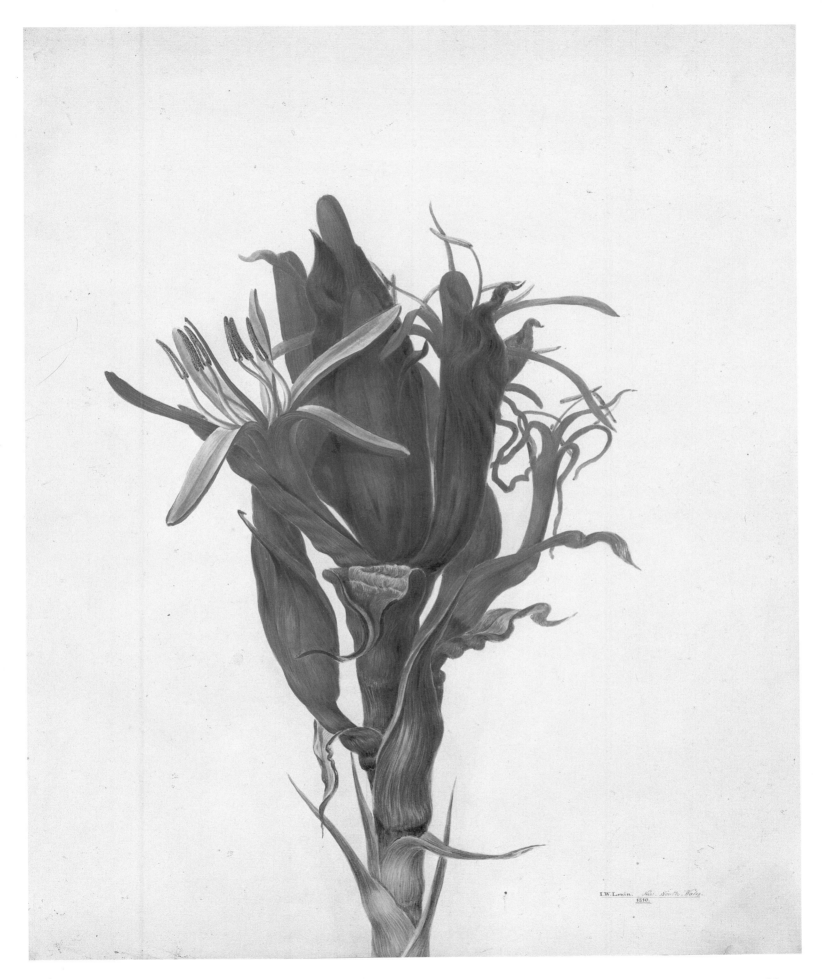

J.W. Lewin. *New South Wales.*
1810.

THOMAS GRIFFITHS WAINEWRIGHT

b. London 1794; d. Hobart 1847

Wainewright was brought up by his uncle, Ralph Griffiths who was publisher of London's *Monthly Review*. After studying art he entered the army for a short while, before taking up journalism.

Wainewright was transported to Australia under rather unusual circumstances. It was alleged in England that he forged his grandfather's will and poisoned his uncle in order to gain his property. He then poisoned his mother-in-law, when she became suspicious, and finally poisoned his wife to claim her insurance. He escaped to France but returned to England six years later, where he was recognised and convicted of forgery.

Wainewright was transported to Hobart, where he was allowed to visit homes as a portrait painter, all the time under guard. He reportedly died of apoplexy at the age of fifty-three.

The Cutmear twins, Jane and Lucy, c. 1840
Watercolour, pencil on paper

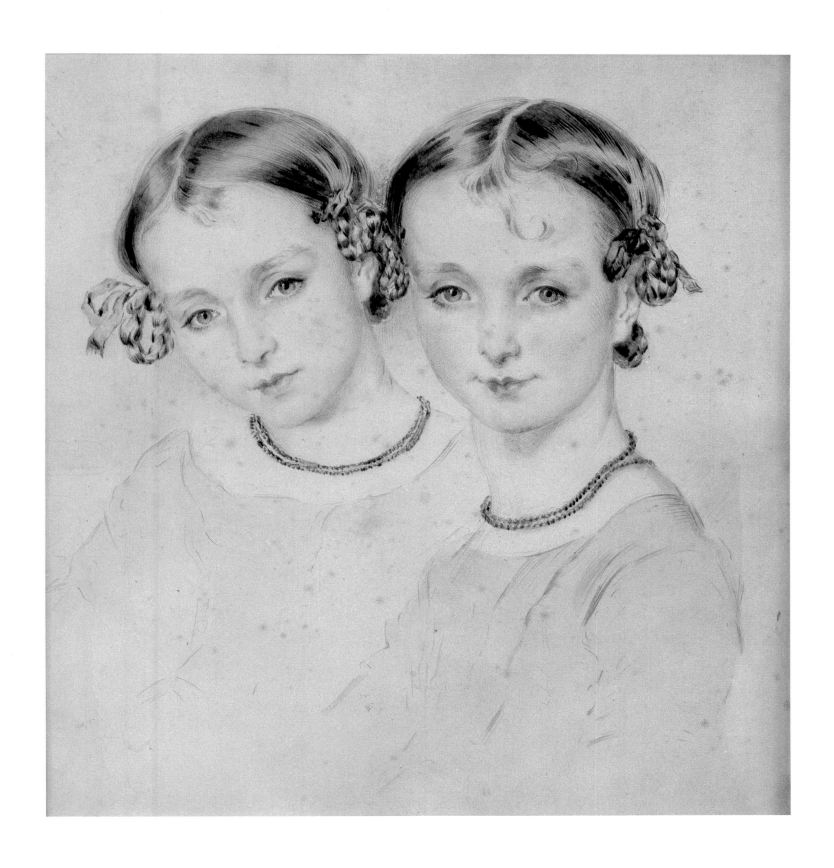

CONRAD MARTENS

b. England 1801; d. Sydney 1878

Born in 1801 in London, Martens studied under Copley Fielding. He later sailed on *The Beagle* with Charles Darwin as a topographic artist, arriving in Sydney in 1835. He set up his studio at The Rocks and from there began to paint his favourite subject, Sydney Harbour. Martens never tired of the harbour views and throughout his life painted numerous studies of it from every possible angle.

Martens knew and loved the work of William Turner and James Mallord. It is the misty, luminous quality of these artists combined with Martens' own topographical precision that characterises his work. He was essentially a water colourist though he was an adequate oil painter.

He worked prolifically and for 25 years supported a family with sales of his work and by art teaching. His paintings appealed to a number of wealthy patrons in New South Wales who were eager to have pictures of local views or their own country houses displayed in their homes. In 1863 he accepted the post of assistant librarian at the New South Wales Parliamentary Library where he worked until he died in 1878.

View of Sydney from Neutral Bay, c. 1857
Watercolour

A View of Sydney and Botany Bay, c. 1855
Watercolour

JOHN SKINNER PROUT

b. England 1806; d. England 1876

John Skinner Prout was born in 1806 and worked as a draughtsman and painter in England. His arrival in Sydney, at the age of thirty-six, heralded a time of awakening appreciation of the arts in the colonies, particularly in Hobart. Considerable interest was aroused when he arranged the first exhibition of paintings to be held in the Legislative Council Chambers in Hobart in 1844. The exhibition was such a success that it led to the building of the first picture gallery in Australia by Robin Vaughin Hood. Two years later a second exhibition was held, this time in the new gallery. Prout also gave a number of lectures in Hobart and Sydney on the theoretical and practical aspects of art.

During the 1840s Prout travelled a good deal around the colonies making picturesque paintings of whatever he saw about him. He began by painting in the academic style of the day where close attention to precise detail was important but during the eight years he spent in the colony his work underwent a noticeable change. From a faithful imitation of nature he graduated towards an interpretation of it, using more assertive strokes of the brush and less of a high finish.

As well as being an artist he was also an active publisher of lithographic landscape prints. The importation of a lithographic printing press from England led to the publication of his *Tasmania Illustrated*. For a short while he moved to Victoria, during which time he contributed to *Views of Melbourne and Geelong*. In 1848 he decided to leave Australia and return to his native England where he became a member of the New Watercolour Society. He continued to work until his death in 1876.

Valley of Ferns, c. 1851
Watercolour

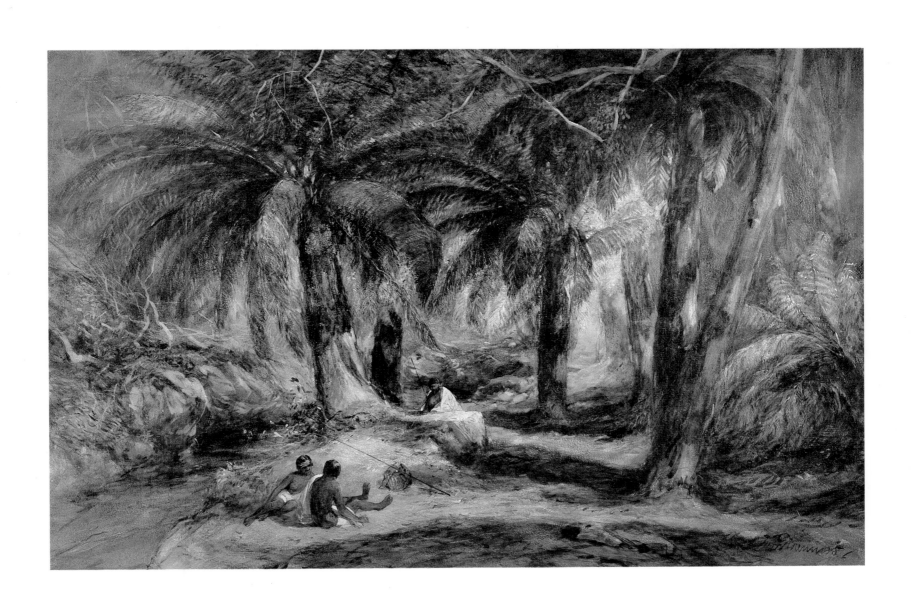

EUGÈN VON GUÉRARD

b. Vienna 1811; d. England 1901

Johann Joseph Eugèn von Guérard was born in Vienna in 1812. He was the son of the Court Painter to Francis I of Austria. He studied art in Dusseldorf and travelled in Italy before arriving in Melbourne in 1852. He visited the Ballarat goldfields and made a number of sketches now to be found in the State Library of Victoria. Mostly he produced landscapes of mountains, waterfalls and properties which were worked with meticulous and almost photographic precision, as may be seen by *A View of the Snowy Bluff on the Wonnagatta River* and *Waterfall, Strath Creek*. There is no doubt that von Guérard's classical training had taught him proficient skills in the treatment of foreground, middle distance and distance but his landscapes of Australia, undertaken with painstaking accuracy, were also designed to be informative and it is for this reason that his subjects received such detailed rendering.

In 1870 he was appointed the first head of Victoria Art School and Gallery, in preference to Louis Buvelot. He taught a number of Australia's up-and-coming painters, including Tom Roberts. He held the position until 1881. In that year he returned to Europe and died in England in 1901.

Mt Kosciusko, 1867
Oil on canvas

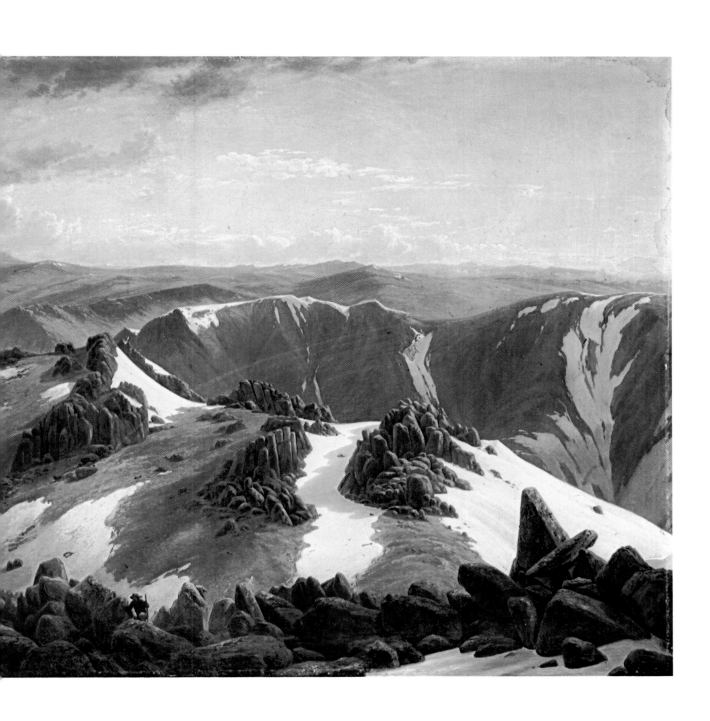

JOSEPH LYCETT

arr. Sydney 1814

Joseph Lycett's date of birth and death are unknown. He was transported to Australia in 1814 as a convict and spent at least ten years in the new colony before his release was secured under the Governorship of Lachlan Macquarie (1809-1821). Macquarie pardoned a number of convicts with artistic bents, including F H Greenway, who was appointed the Government Architect, and M M Robinson, Australia's only Poet Laureate.

Lycett's work represents a significant contribution to early topographical illustration in the colony. He produced over 50 aquatints of the local scenery and architecture and on his return to England had them published by J Souter in twelve monthly magazine parts. Accompanying each print was a text supplying details on such matters as were likely to interest the readers. They might be botanical, geographical or architectural. They might discuss the situation of a house, who lived in it, how and when it was built. Their appeal lay in the English curiosity about the new continent and a desire to see it in a far-away, romantic light. Lycett's *Views of Australia and Van Diemen's Land* fulfilled this function. It is for this series that Lycett is principally remembered.

However, during his time in Australia he was employed by early free settlers, such as the members of the New South Wales Corps, to draw their new country houses, some of which were as imposing as many of the finest houses in England. Anxious to please his patrons Lycett never omitted to give his topographical work the required tinge of romantic sensibility. This fashion of owning an engraving of one's own home had originated in England but it was to form an important feature in the work of early Australian artists and was to supply them with a source of income. Macquarie also commissioned work from Lycett.

Raby, a farm belonging to Alexander Riley, Esq., c. 1820
Watercolour on paper

LOUIS BUVELOT

b. Switzerland 1814; d. Victoria 1888

Louis Buvelot is often considered to be the 'father of Australian landscape painting'. His treatment of local colour and light drew him to the attention of a number of up and coming young artists in Melbourne who were later to become the Australian Impressionists of the Heidelberg School. He, like his friend Julian Ashton, preferred to work in the open air and it was from this practice that he derived a special interest in light and its source.

Buvelot was born in Switzerland in 1814. He studied in Switzerland and Paris and worked successfully as a portrait and landscape photographer in Brazil. On his arrival in Melbourne in 1865 he set up another photographic venture but his wife's income allowed him to concentrate more and more on his painting. In addition to working outside in natural light, a familiarity with photography doubtless drew him to a close examination of light. Photography may also account for his observation of fine detail. Often the silhouettes of branches are meticulously painted against a golden or blue clouded sky.

Though keenly aware of the effects of light and atmosphere, Buvelot still adhered a good deal to the traditional schools of painting with their dark, heavy masses of trees and earth. His usual subjects were settled farmlands as well as the wildness of the bush. This dignified mode of painting, though not always pleasing to the Australian Impressionists was of considerable influence.

In 1888 Buvelot died in Victoria. His paintings *By the Creek* and *Between Tallarook and Yea* can be seen in the National Gallery in Melbourne.

Winter Morning, near Heidelberg, c. 1869
Oil on canvas

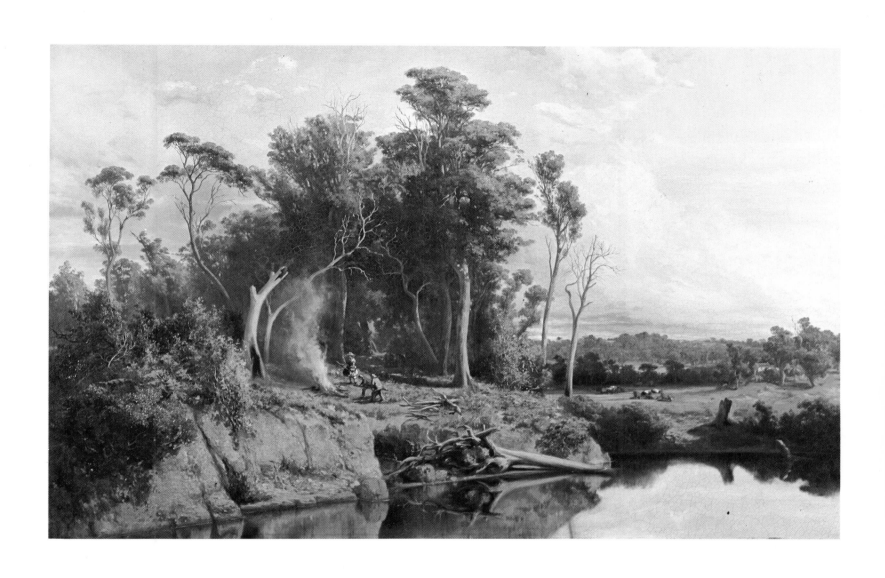

The Woolshed near Camperdown,
Oil on canvas

S.T. GILL

b. England 1818; d. Melbourne 1880

A self-taught artist who was born in England in 1818, he came to Adelaide at the age of 21. Although born an Englishman, Gill adapted himself easily to the lifestyle of pioneering Australia. He knew a good deal about horse flesh, gold digging, gambling, drinking and staying alive in the bush. He was a good-natured man who identified with the people he sketched.

During his first 12 years in Australia Gill remained based in Adelaide, but when gold was discovered in Victoria in 1851 he joined the flocks of diggers and settled in the goldfields. It is doubtful whether Gill ever looked for gold himself. Instead he produced a series of sketches which were published in 1852. These showed, in the greatest detail, what life in the goldfields was really like. Gill became well-known in the 1850s for this series and produced others which were published as engravings or lithographs.

Gill's paintings are filled with activity and humour, depicting boxing matches, auctions, expeditions, church attendances and other occupations in the colony at this time. Often caricature and satire peep from beneath the surface of his work but rarely at the expense of factual evidence. He produced sketches for the *Victoria Illustrated* and the Melbourne magazine, *Punch* and became a popular artist and chronicler of his era — but Gill was far more than a mere illustrator. There are many who consider that the lithographs and watercolours he produced in the 1840s in South Australia were of higher artistic value than the more famous, later sketches and paintings of the goldfields. Gill died suddenly after he collapsed on the steps of the Melbourne General Post Office in 1880.

Sturt's Overland Expedition leaving Adelaide, 10th August, 1844, 1844
Watercolour

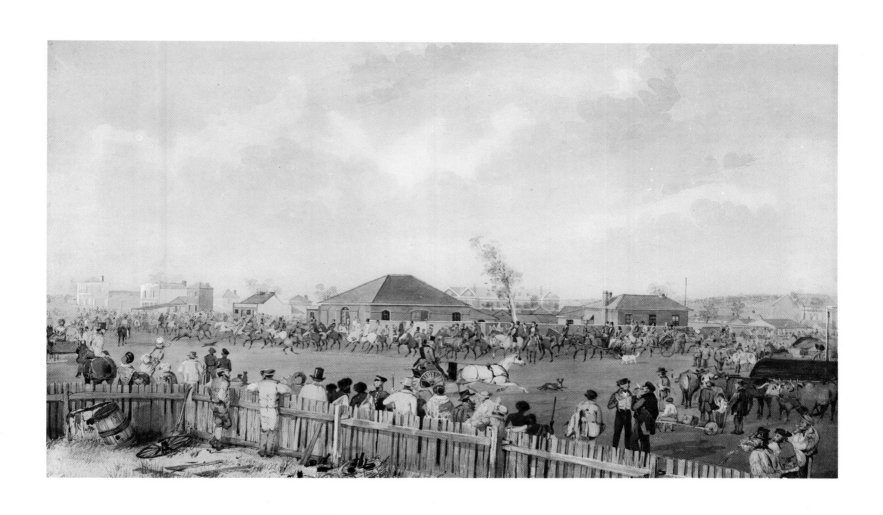

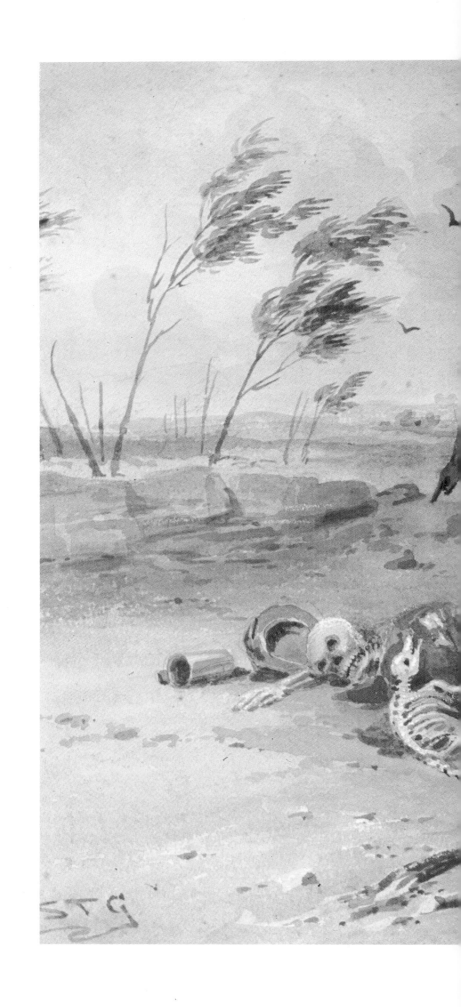

Grim Evidence, c. 1855
Watercolour

42

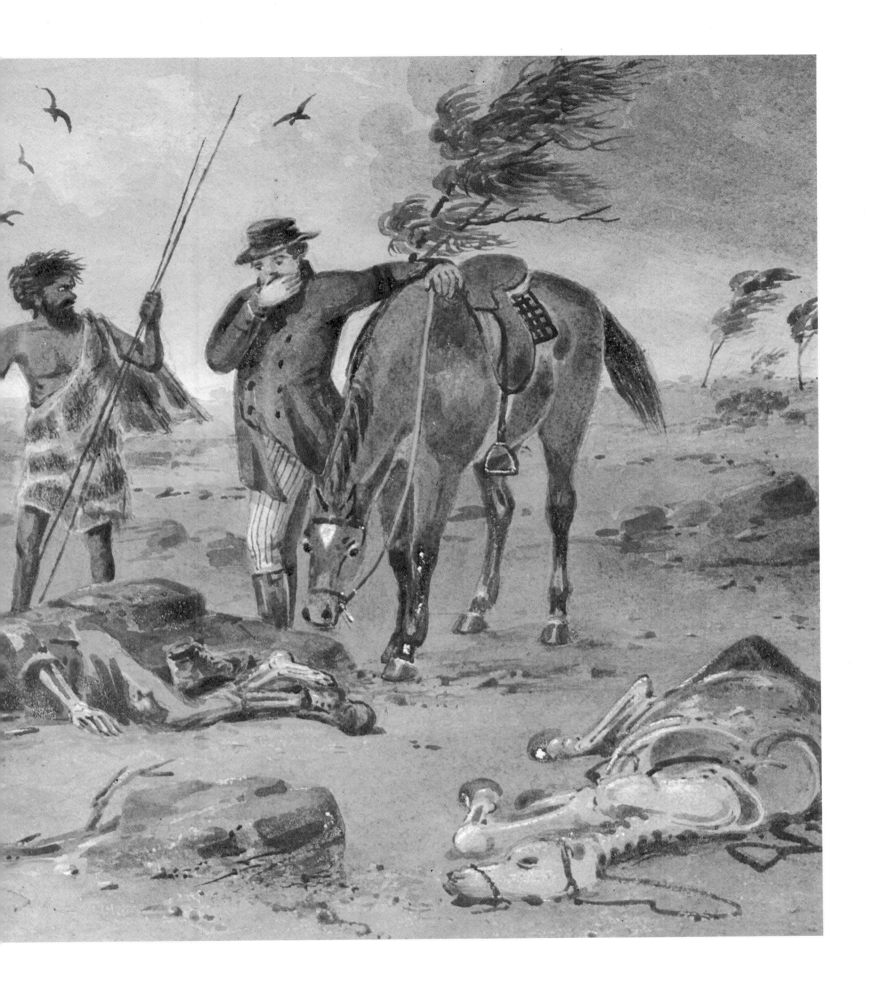

WILLIAM STRUTT

b. England 1825; d. England 1915

Strutt arrived in Australia in 1850, as gold fever was sweeping the colonies. Like many others he travelled to Ballarat, where he made numerous sketches.

His best known work, *Black Thursday*, is of the bushfires that ravaged the Victorian colony in 1851. It was painted in London some years after the event from a series of sketches he had made. Strutt's skills as a draughtsman were well illustrated by this work, and another epic, *The Start of the Burke and Wills exploring expedition from Royal Park, Melbourne, August 20, 1860.*

After his return to England in 1862, Strutt worked quite successfully as a religious artist, exhibiting regularly with the Royal Academy before his death in 1915.

The Start of the Burke and Wills exploring expedition from Royal Park, Melbourne, August 20, 1860, 1860
Pencil and watercolour

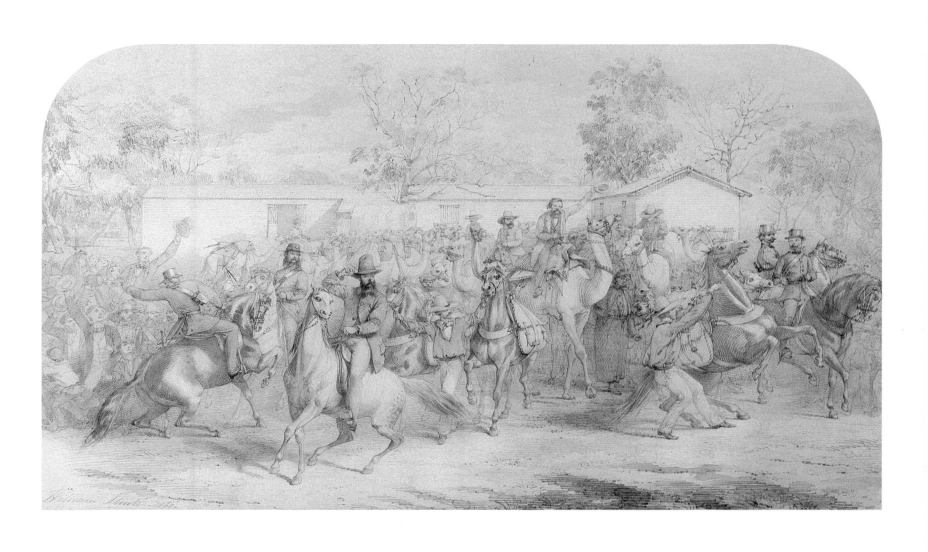

WILLIAM PIGUENIT

b. Hobart 1836; d. Sydney 1914

Piguenit was a native-born Tasmanian of French descent who worked as a surveyor with the Tasmanian Survey Department until he was 36. His employment there enabled him to explore suitable settings for his paintings and gave him a knowledge and understanding of photography. Though briefly studying under Frank Dunnett he was largely a self-taught artist.

Piguenit's preference in both subject matter and style was more for romantic classical themes than those preoccupying his contemporaries. He was inspired by dramatic landscapes and liked to paint tortuous mountains, stormy skies and flooding lakes. In his style he sought to communicate the grandeur and power of nature and to evoke a sense of wonder at its mysterious ways. Although seemingly conventional, his approach to creating an illusion of distance did not conform to the devisive methods of traditional landscape painting. He ignored accepted techniques for linking sky with water and foreground with middle distance and his oil painting *The Flood in the Darling* illustrates this well.

Piguenit contributed to exhibitions at the New South Wales Academy of Arts on a number of occasions and to a show at the Grafton Gallery in London on Australian art. His painting, *Mount Olympus, Lake St Clair, Tasmania* was his first to be acquired by the Art Gallery of New South Wales.

He died in Sydney, leaving behind him unsold works which he requested be destroyed rather than sold. His wishes were complied with but his work can still be found in provincial and State galleries, particularly that of the Art Gallery of New South Wales.

The Flood in the Darling 1890, 1895
Oil on canvas

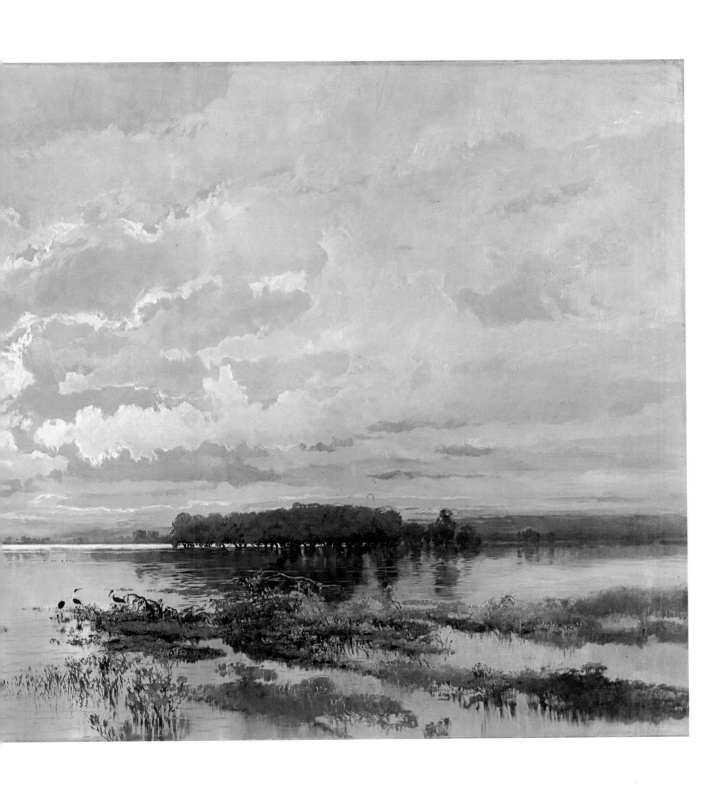

JULIAN ASHTON

b. England 1851; d. Sydney 1942

Julian Ashton arrived in Melbourne in 1878 to take up the post of illustrator on the *Illustrated Australian News*. He was born in England in 1851 of an Italian mother and American father and studied at the West London School of Art and the Academie Julien in Paris. He was typical of a new generation who were coming out to the colony seeking to make a living as artists.

In Melbourne he found himself neighbours with Louis Buvelot. Both were advocates of working outside the studio — an unconventional notion at the time. The painters who adhered to this new idea were called plein-air painters and the next 10 years were to witness a growing trend in this direction. Ashton wanted to break away from imitating the 'great masters' of the past. He preferred to paint life as he saw it, stripped of romance. To draw Ned Kelly he went to his trial and sketched him as he sat in the courtroom.

In 1883 he moved to Sydney to work for the *Picturesque Atlas* and later he became a staff artist on the *Bulletin*. His sketches of this time were done during the weekends around Sydney Harbour, along the beaches or up the Hawkesbury River. His work reflects the skills of a draughtsman but contains an added painterly touch. There was also a documentary quality to the subjects he chose.

He founded the Sydney Art School, or Julian Ashton's as it was then known, and taught a refreshingly new, unacademic approach to painting, inspiring such pupils as Syd Long and Rah Fizelle. From 1886-92 he was President of the Art Society of New South Wales and from 1889-99 he was Trustee of the Art Gallery of New South Wales. He persuaded the Government to allocate more funds for the purchasing of Australian works of art and with such funds he bought Streeton's *Still Glides the Stream and Shall Forever Glide* for the gallery. He also arranged for the first Australian art to be sent overseas for exhibition and sale. In 1924 he was awarded the New South Wales Society of Artists medal and in 1938 the Sydney Sesqui-centenary prize for watercolour. Ashton's enormous energy and enthusiasm for Australian painting and artists remained unabated until his death in 1942.

A Solitary Ramble, 1886
Watercolour

48

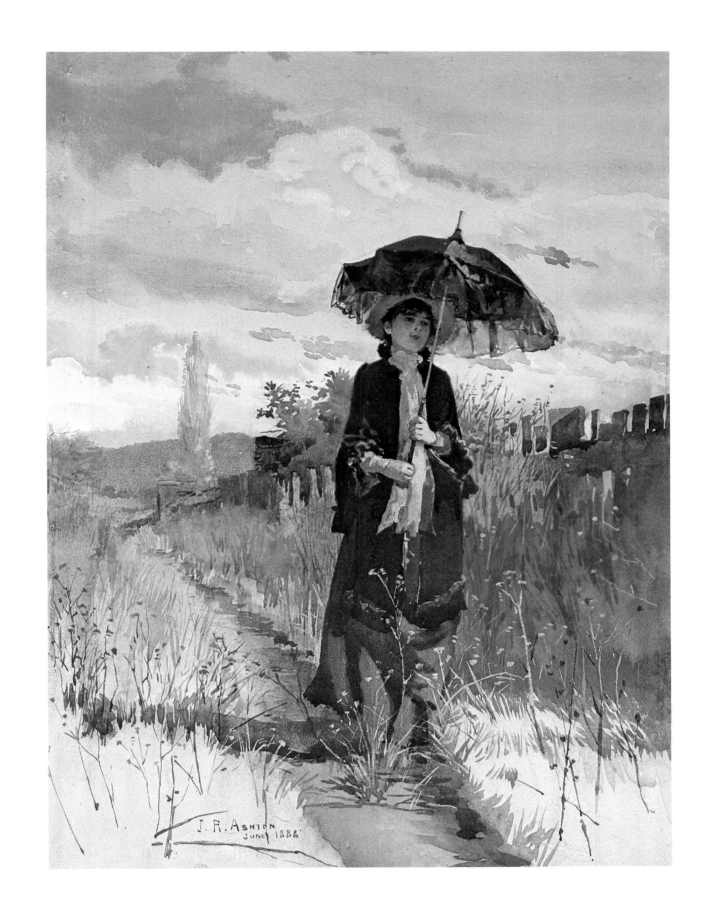

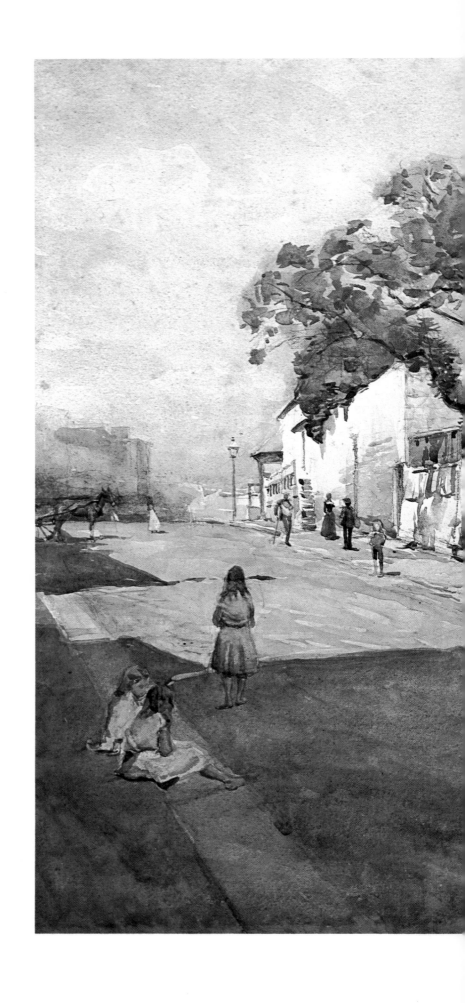

Old Sydney, Cumberland Street, c. 1895
Watercolour

FRED McCUBBIN

b. West Melbourne 1855; d. Melbourne 1917

An outstanding impressionist landscape painter of the famous Heidelberg School, Frederick McCubbin was born in West Melbourne and worked in the family bakery before deciding upon a career in art when he was 22 years old.

He studied at the Artisan's School of Design and the National Gallery School, both in Melbourne. Together with artists Tom Roberts and Arthur Streeton, McCubbin founded an artists' colony outside Melbourne which was greatly influenced by the French Impressionist style.

However, McCubbin modified the French style, using direct sketching in oils which emphasised Australian light conditions. He portrayed the Australian bush and its pioneers in melancholy terms in such works as *The Lost Child, Down on His Luck* (1889) and *A Bush Burial* (1890). Another gloomy picture from his early period is *Old Stables*.

McCubbin showed there was more to his work than misery when he produced the more high-keyed *Winter Sunlight* and *View towards Melbourne from the Yarra*. His celebrated triptych *The Pioneers* was bought for the National Gallery of Victoria in 1906.

McCubbin visited Europe in 1907 where he was overwhelmed by the canvasses of the masters, particularly Rubens, Turner and the Venetian painters. On his return to Australia he painted no more large works but rather concentrated on small, intimate pictures of city streets and landscapes in pure French Impressionist style.

A McCubbin Memorial Exhibition was held at the National Gallery of Victoria in 1955. McCubbin was a teacher at the Melbourne National Gallery School from 1886 until his death in 1917. He was survived by three sons who were also prominent in the arts.

The Lost Child, 1886
Oil on canvas

Old Stables, c. 1880–1885
Oil on canvas

TOM ROBERTS

b. England 1856; d. Kallista 1931

The most prominent member of the famous Heidelberg School, Tom Roberts was an Impressionist painter whose skill and artistry has rarely been surpassed in this country.

Roberts was born in England and arrived in Melbourne in 1869 where he attended the Artisans' School of Design, Collingwood and the National Gallery Art School.

During a walking tour of the south of France in 1881 Roberts was introduced to the Impressionist technique of painting and upon returning to Australia, set up an artists' colony in conjunction with Fredrick McCubbin at Box Hill and Heidelberg outside Melbourne. They were among the first in Australia to paint landscapes in the open rather than from sketches in the studio.

The group grew to include Charles Conder and Arthur Streeton and in 1891 they moved to Mosman, Sydney where they painted scenes of the harbour and surrounding countryside.

Roberts tackled heroic and national subjects such as *The Shearing of the Rams* (1890) and *Bailed Up* (1895). His work is distinguished by a crisp, clean brush which gave his paintings spontaneity and vitality. The combination of light and suggestion of heat in *Bourke Street* and the delightful *Thunderbolt at Paradise Creek* reveals the quality of his work. Roberts versatility also extended to superb portrait painting such as *Eileen* and *Madame Pfund*.

In 1901 Roberts was commissioned to produce a large commemorative painting of the opening of the first Federal Parliament in Melbourne. He served with the RAMC in England during World War I and returned to Australia in 1923 where he did much to raise the standard of art in this country.

Roberts died at Kallista, Victoria in 1931 without having received any official honours.

Bushranging: Thunderbolt at Paradise Creek, c. 1894
Oil on canvas

Bailed Up, 1895,1927
Oil on canvas

Holiday Sketch at Coogee, 1888
Oil on canvas

DAVID DAVIES

b. Ballarat 1862; d. England 1939

In 1862 David Davies was born in Ballarat. He first studied at the Ballarat School of Design and then went on to the National Gallery School in Melbourne. He exhibited for the School Travelling Scholarship and found himself in Paris in 1892. Later he moved to St Ives in England where a colony of cosmopolitan artists lived and worked. The plein-air landscape painters there looked towards the French Barbizon school for inspiration as well as being aware of the Impressionist movement in Paris. Here, with the healthy exchange of ideas and techniques, Davies was able to develop his own artistic vision.

He returned to Australia in 1894 and settled at Templestowe. Here he began to produce his greatest Australian work. He painted a series of landscapes bathed in soft light, either in early morning or evening, where the earth appears strong and powerful so that the work itself is biomorphic.

The symbolic nature of earth as lifegiver, in which Davies believed, is contrasted with the stippled, broken colour effect with which the paint has been applied. In paintings such as *A Summer Evening* and *Moonrise, Templestowe* the canvas seems to pulsate with the vitality of the earth and the grass that springs from it. Although the luminous and muted colours of Davies' palette were clearly influenced by Impressionism and the members of the Heidelberg School were his contemporaries, he did not regard himself as part of any particular movement.

In 1897 Davies went to live in Cornwall, Wales and France before finally settling in England where he lived for nine years, until his death in 1939.

Moonrise, Templestowe, 1894
Oil on canvas

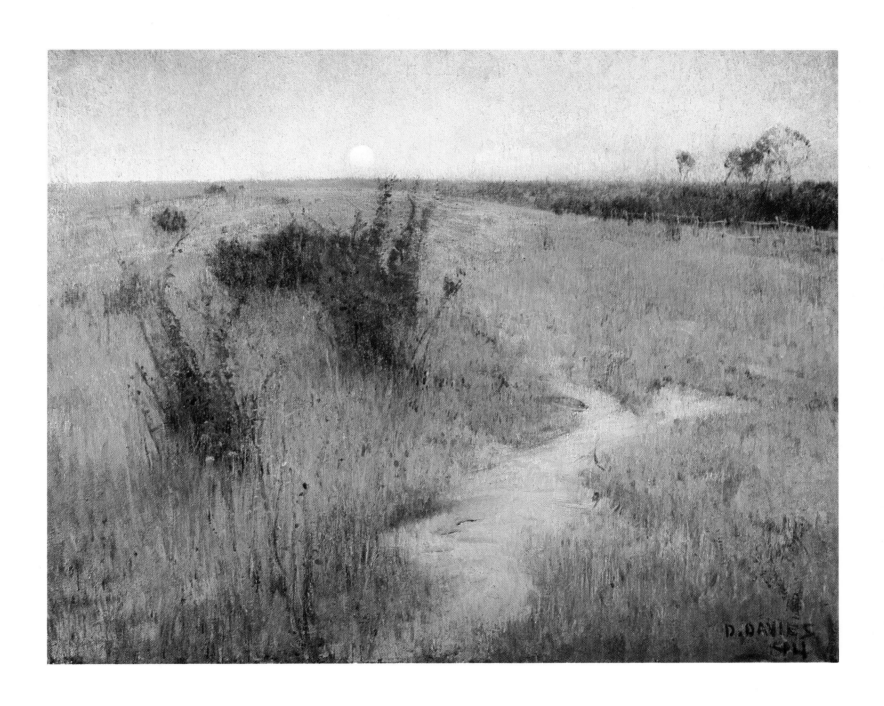

Golden Summer, 1888
Oil on canvas

RUPERT BUNNY

b. Melbourne 1864; d. Melbourne 1947

Rupert Bunny spent most of his working life abroad, mainly in France. He was one of the first students to attend the Melbourne National Gallery school, then he went on to study at Caledron's, St John's Wood, London in 1884-1885. In 1885 Bunny went to Paris and studied under Jean Paul Laurens.

Chiefly inspired by the Renaissance masters, Bunny also came under the influence of French Impressionists and Neo-Classicists. He was a particularly civilised and cultivated man which showed up in his work.

His best known works, such as *The Rape of Persephone*, are basically mythological in source. They echo the ideas and sentiments of the Pre-Raphaelites in their high colours and refined graceful figures. Bunny's mythological works tended to obscure his versatility to the public. His full range was not appreciated until 1946 when the National Gallery at Victoria exhibited a wide cross-section of his work. Here the quality of his landscapes, in the style of Cézanne, and line drawings, inspired by Rodin, were seen and recognised for the first time.

A summer's morning, c. 1908
Oil on canvas

E. PHILLIPS FOX

b. Melbourne 1865; d. Melbourne 1915

Born in Melbourne in 1865, he studied at Melbourne National Gallery School before leaving for Paris at the age of 21. There he met students from Julian's and the École des Beaux Arts where Impressionism, the great European art movement of the time, was in full swing. His contact with John Russell, an Australian expatriate, led to a painting trip in Brittany where Fox became the student of plein-air painter, Thomas Alexander Harrison. He exhibited in the Paris Salon in 1890 and returned to Melbourne in 1892.

He established the Melbourne Art School and taught French Impressionist ideas and techniques for handling pigment and exploiting broken complimentary colour. He encouraged his students to experiment with their paints and to seek new ways of making colour vibrate so as to bring life to the canvas.

Travelling to Europe again, this time to London, he completed the *Landing of Captain Cook*, commissioned by the Trustees of the National Gallery of Victoria. He spent time in Spain, Italy and France accompanied by his wife, Ethel Carrick, who was a painter in her own right.

Fox's subjects varied widely. *The Ferry*, completed in 1911, demonstrates his ability to depict a lively and bold composition of figures bathed in strong, midday sun while *Moonlight, Heidelberg* is devoid of figures and dwells in an airy, nocturnal world of ghostly serenity. For other paintings he chose the subject of the nude. Fox exhibited his work in Melbourne in 1908 and in Sydney in 1913, two years before his death.

The Ferry, 1911
Oil on canvas

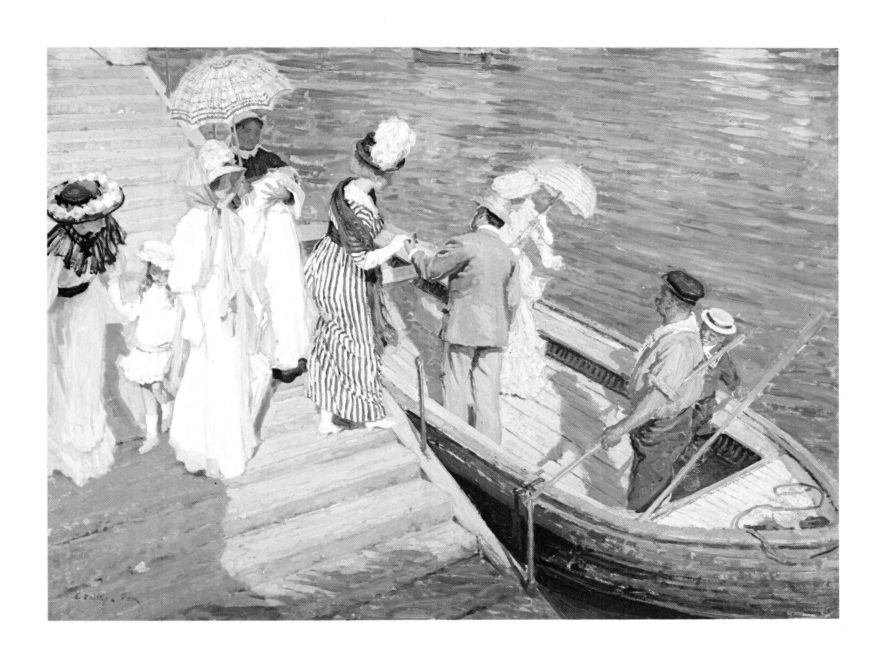

Moonrise, Heidelberg, c. 1900
Oil on canvas

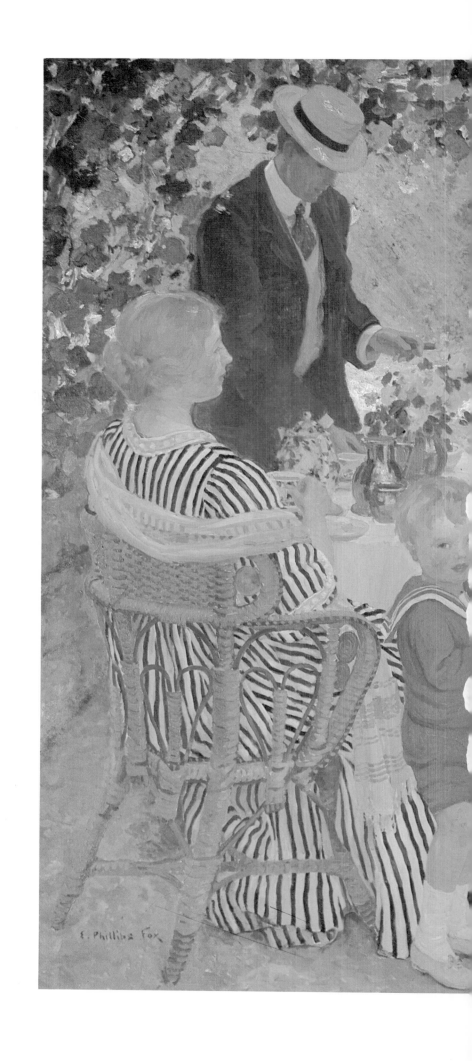

The Arbour, 1911
Oil on canvas

72

ARTHUR STREETON

b. Mount Duneed 1867; d. Olinda 1943

The celebrated landscape artist Arthur Streeton was a member of the famous Heidelberg School of painters which included Tom Roberts and Frederick McCubbin. Streeton was born at Mount Duneed, Victoria and while working as a lithographer by day, studied at night at the National Gallery School, Melbourne.

In 1886 he joined the artists' camp at Box Hill near Melbourne where he produced many fine paintings. Streeton was perhaps the first Australian painter to persuade Australians that theirs was a golden landscape of leisurely rivers, blue sky, and blue-shadowed eucalypts with a unique, indigenous beauty.

Streeton's first success was *Still Glides the Stream* which he sold to the Art Gallery of New South Wales in 1890. More than any other painter of the Heidelberg School, Streeton convinced Australians that English oaks and elms were not the sole prerequisites of excellence in landscape painting.

Streeton moved to Sydney in 1890 and with Tom Roberts established an artists' camp on the harbour foreshores at Mosman where he made many sketches of the scenery and beaches around the harbour. His large pictures *Fire's On, Lapstone Tunnel* and *The Purple Noon's Transparent Might* won wide acclaim and after a successful exhibition in 1898 in Melbourne, Streeton left for England.

He returned to Australia in 1907 without having achieved any significant success abroad although he was awarded the Paris Salon gold medal of 1908. During World War I Streeton served with a medical unit, then as an official war artist.

He finally settled in Victoria in 1924 and won the Wynne Prize in 1928. Streeton spent his last years writing to newspapers deploring the lack of Australian representation in the National Gallery of Victoria and acting as art critic for the Melbourne *Argus*. He died at Olinda in 1943.

Fire's On, Lapstone Tunnel, 1891.
Oil on canvas.

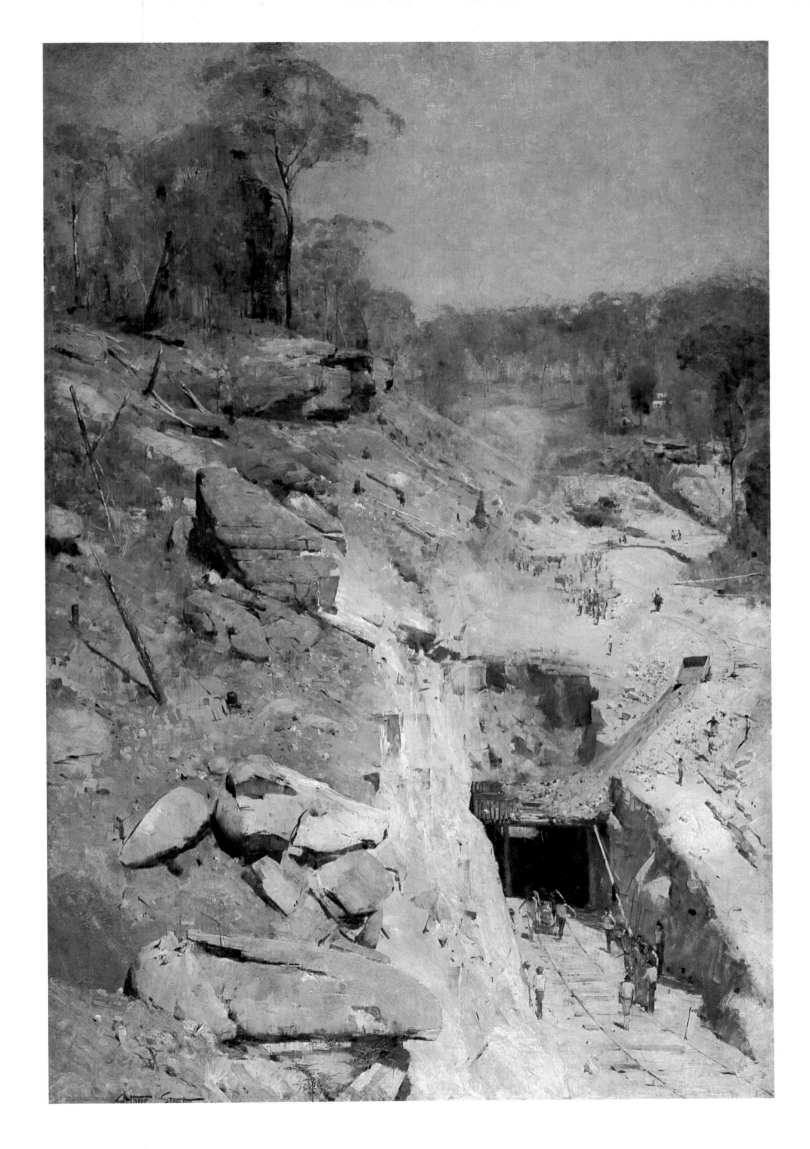

CHARLES CONDER

b. England 1868; d. 1909

Charles Conder was born in London in 1868. He spent a part of his youth in India and when he was seventeen he came to Sydney to work with his uncle in the Land Department and later in a survey camp. He studied art at night school under Alfred Daplyn and met the Italian Impressionist painter, Girolamo Nerli, who greatly influenced his thinking about the nature and purpose of art.

In 1888 Conder left Sydney and accepted Tom Roberts' invitation to join the summer artist camp at Eaglemont. Here he found Arthur Streeton, Fred McCubbin and Roberts all working in a new, plein-air style which bore a striking resemblance to French Impressionism. Conder, only twenty years old at the time, absorbed their ideas on light, space and decorative brushwork and the four of them became known as the Heidelberg School. They experimented, taught and learnt from one another and for a couple of years the group remained tightly-knit. In August 1889 they challenged the conventional schools of art in their famous 9×5 Impressions Exhibition. Most of their work had been executed on the lids of tobacco boxes, the approximate measurements of which were 9″×5″, so the title of the exhibition. The reaction of the public was mostly one of shocked dismay and one or two of the critics were unequivocally scathing. Conder contributed forty-six of the one hundred and eighty exhibits and designed the cover for the catalogue.

In 1890 the group broke up and Conder left for Europe, never to return. He went to Paris and to London and in both cities established a reputation as Australia's first Bohemian. He became a sophisticated dandy with a passionate interest in aestheticism and women. It is generally considered these days that Conder frittered away his talent in Europe painting decorative fans and screens while his work in Australia was of a far more serious and significant kind.

Conder suffered from poor health for many years and the last three years of his life were spent in hospital. He died in 1909 at the age of 40.

Herrick's Blossoms c. 1888
Oil on cardboard

GEORGE LAMBERT

b. Russia 1873; d. Cobbity 1930

The son of an English woman and an American architect in the court of the Russian Tsar, Lambert was born in St Petersburg, Russia — today's Leningrad — in 1873 and arrived in Australia in 1887. With his widowed mother he settled on a property at Eurobla, New South Wales. While working as a station-hand, he began drawing and sent samples of his work to the *Bulletin*, in Sydney.

He enrolled at Julian Ashton's Académie in 1896; during his four-year study there he became one of Ashton's favourites. Having won a scholarship in 1900, he went to Paris and studied at Collarossi's for a year.

Lambert's exceptional talent and flamboyant personality saw him dominate the local scene throughout the 1920s. His style showed the influences of some Renaissance masters, such as Manet and Velasquez. Hints of these influences are wonderfully intertwined in many of his works.

In the classic tradition of the Renaissance, Lambert sought and gained excellence in many art forms, from drawing to sculpture.

Miss Thea Proctor, 1903
Oil on canvas

MARGARET PRESTON

b. Adelaide 1875; d. 1963

Born in Adelaide in 1875, Preston was one of the rebels of Australian art. From a very early stage of her career she defied the art establishment which unquestionably accepted all the traditions of Europe. With her husband she travelled extensively throughout Australia, Europe, the Middle East, Africa and the Pacific. Preston's travelling inspired and multiplied her desire for independent art forms, rather than stereotyped imitations of Europe.

The influence of Aboriginal bark painting can be seen clearly in Preston's work, surfacing in the crisp lines, simple forms and reduced number of colours. Preston was quite forthright about her work and never hesitated in expressing her opinions. 'In my effort to give a feeling of sharp flatness,' she said 'I force my compositions with as much solid light as possible. I am trying to suggest size and to do this I am eliminating distracting detail.'

Although Preston gained recognition as a painter of still lifes, she was also skilled in wood-cut and linocut printing, areas where the Aboriginal influence again shows through.

A member of various societies and associations, Preston received a silver medal at the Paris International Exhibition of 1937: a fitting reward for one who gave much to Australian art.

Western Australian gum blossom, 1928
Oil on canvas

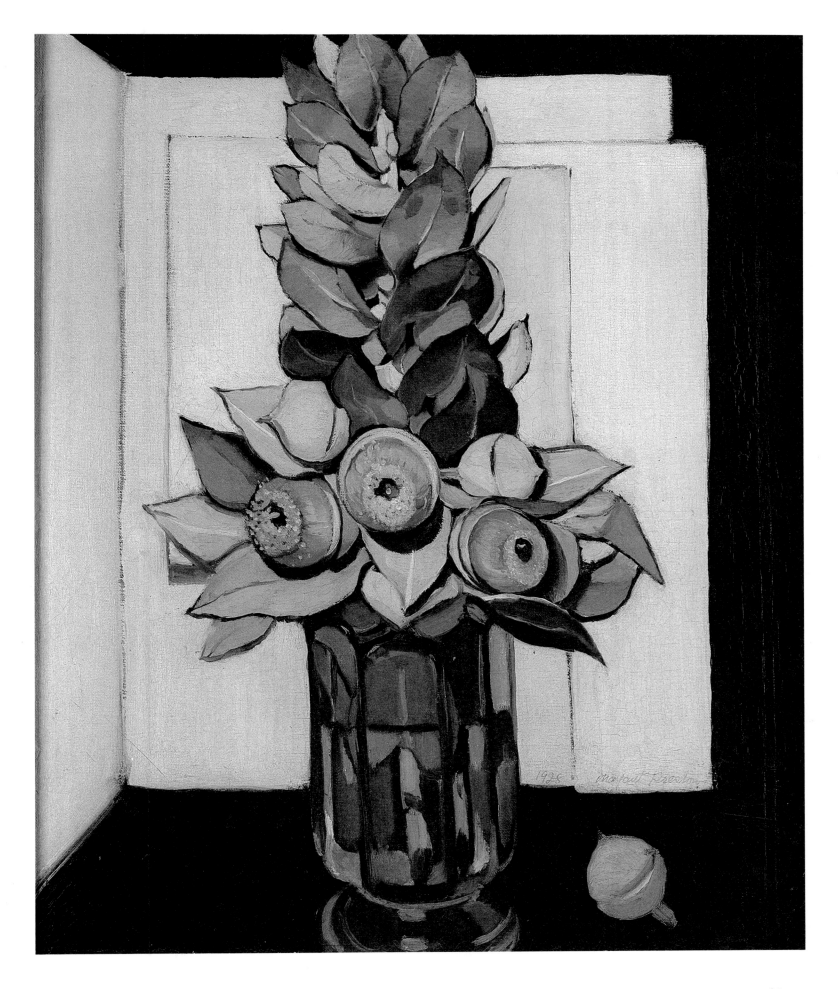

MAX MELDRUM

b. Scotland 1875; d. Melbourne 1955

In the first half of the twentieth century, Duncan Max Meldrum was a controversial figure in the Australian art world. Born in Edinburgh in 1875 he arrived in Melbourne when he was only 14. After studying at the National Gallery School he received a travelling scholarship award in 1899 and went to Paris where he enrolled at Academie Julien. The teaching at the academy was not to his taste and he spent most of his time in the Louvre Museum absorbing the work of Rembrandt, Corot and particularly Velazquez.

Returning to Melbourne in 1913 he founded his own school and began expounding his theory of art, which was to become known as 'Tonal Impressionism'. In his thesis, *The Invariable Truths of Depictive Art*, he says that art is a pure science and should remain impersonal, applying itself exclusively to the task of transposing the three-dimensional vision of reality onto a two-dimensional plane — the artist's page or canvas.

Meldrum was a fiery character, a fine craftsman and a pacifist through World War I. His theory attracted a cult following among many Australian artists.

His early paintings, such as *Picherit's Farm* and the portrait of his mother display great warmth and sensitivity. Meldrum later became President of the Victorian Arts Society. In 1931, after lecturing in Europe and America, he returned again to Melbourne and took up the appointment of Trustee of the National Gallery of Victoria. He won the Archibald Prize twice during his lifetime and remained a respected member of his profession up to the time of his death in Melbourne in 1955.

Picherit's Farm, 1910
Oil on canvas

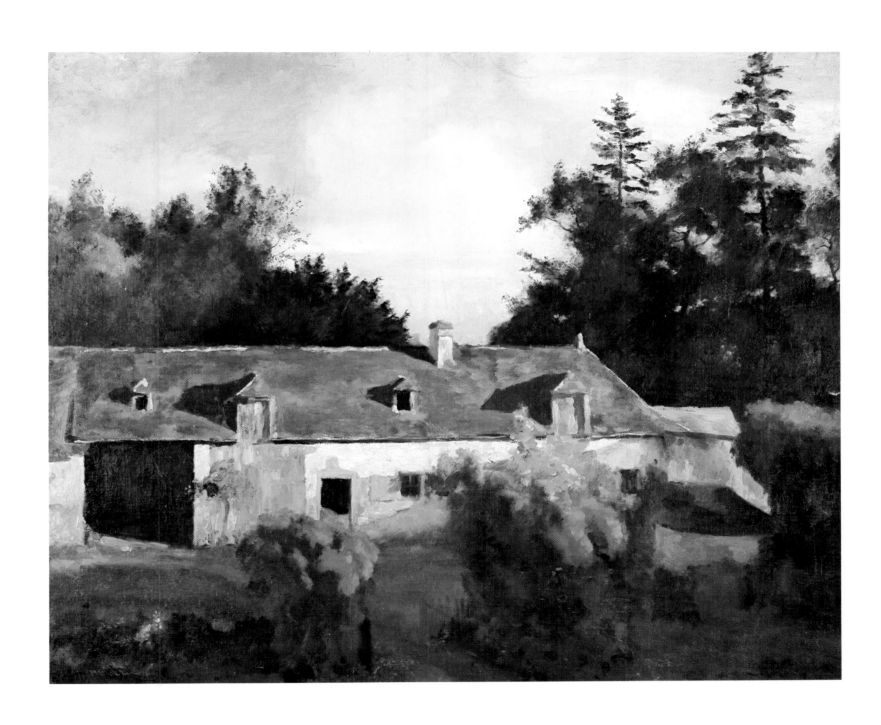

HANS HEYSEN

b. Germany 1877; d. Hahndorf 1968

The popular landscape painter renowned for his bush scenes dominated by massive gum trees, Hans Heysen was born in Hamburg, Germany and arrived in Australia at the age of seven.

He left school at 14, worked for a time at a sawmill, then a hardware business before studying under James Ashton at the South Australian School of Design. He decided upon a full-time painting career in 1899 and that same year won a gold medal for drawing before leaving Australia to study in Paris.

Heysen exhibited in London and at the Paris Salon and travelled throughout Europe before returning to Australia in 1903. From the time of his first exhibition at the Guild Hall in Melbourne in 1908, Heysen's popularity grew with the Australian public.

He moved to Hahndorf in South Australia's Mount Lofty Ranges and over the next 50 years used the vibrant surrounding countryside as themes for his work. A visit to the Flinders Ranges in 1929 inspired such works as *Foothills of the Flinders*, *Red Gums of the Far North* and *In the Flinders Ranges*. Heysen mastered the painting and drawing of massive gum trees and the light and shadow which falls on their trunks and peeling bark.

Heysen worked in watercolours, oils and charcoal and works such as *Sunshine and Shadow* and *The Hill of the Creeping Shadow* display an endless preoccupation with light. His excellent landscapes were awarded the Wynne Prize nine times between 1904 and 1932.

Heysen was a founder member of the Australian Academy of Art and in 1940 joined the board of the National Gallery of South Australia. His work can be found in all State galleries and in the British Museum.

Heysen was appointed an OBE in 1945 and was knighted in 1959. He died at Hahndorf in 1968.

The Three Sisters of Aroona, 1927
Watercolour

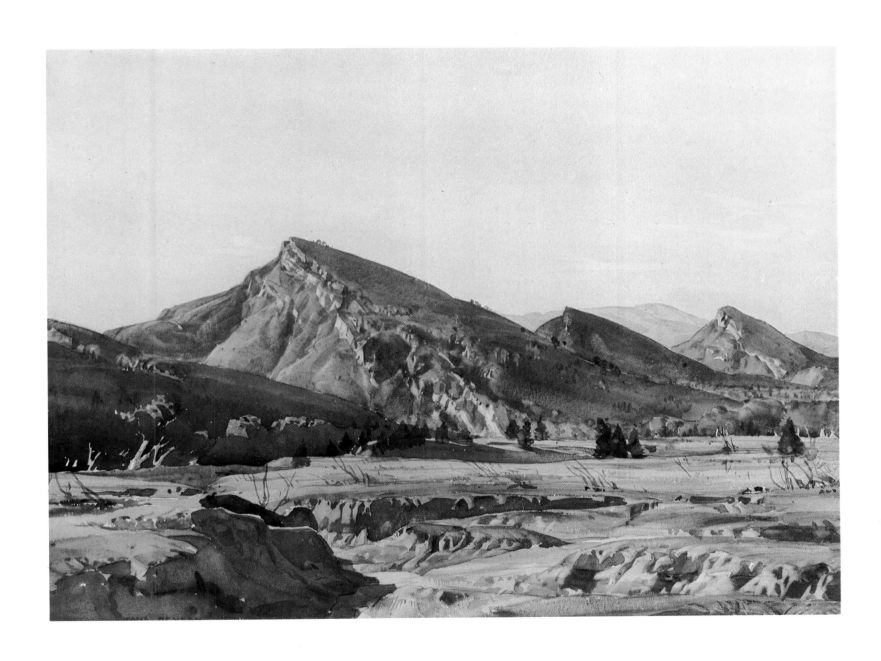

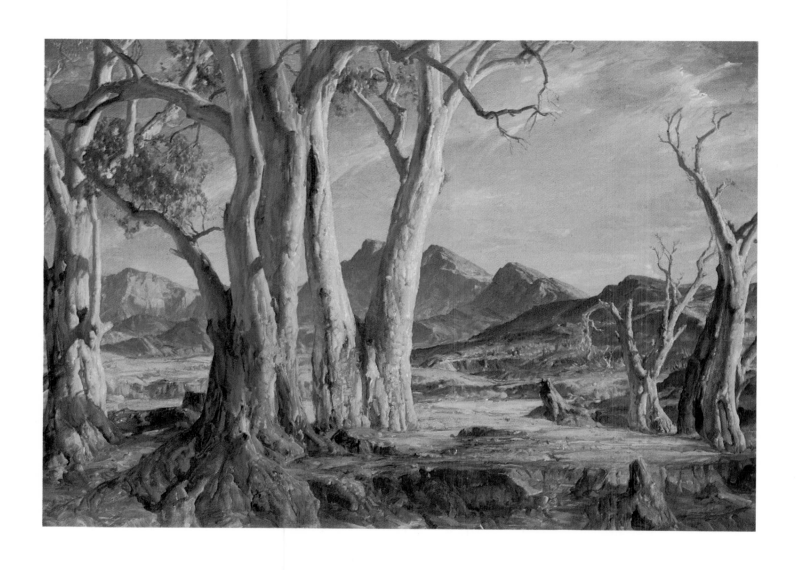

In the Flinders Ranges — Far North, c. 1950
Oil on canvas

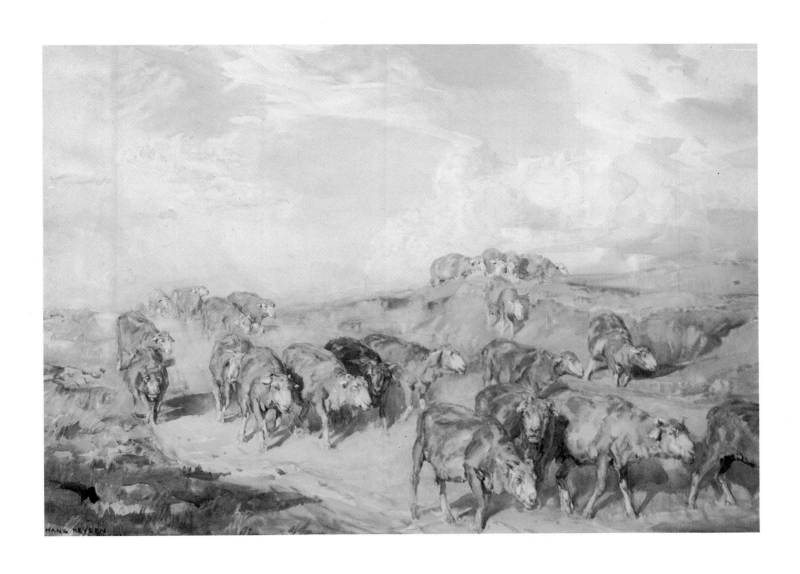

Drought Sheep, 1916–21
Watercolour

HUGH RAMSAY

b. Scotland 1877; d. Melbourne 1906

Hugh Ramsay lived only 29 years but during his short lifetime he produced a number of works of impressive maturity. He was born in Glasgow, Scotland in 1877 and came to Australia when he was eleven years old. For four years he studied under Bernard Hall at the Melbourne Gallery School and in 1901, at Sir John Longstaff's instigation, he went to Paris to study at Colarossi's. Ramsay spent much of his time in the Louvre, making copies of the Old Masters. He was especially inspired by Velasquez. Other painters having a profound effect upon him at this stage were Manet, Sargent and Whistler. A year after his arrival in Paris he contracted tuberculosis and was forced to return to Australia.

The influences of Manet and Velazquez are unmistakable in such paintings as *The Foil* and *Jeanne*. The effortless blend of the rich and subdued colours with the subject marks these as exceptionally accomplished works. Their technical virtuosity and the tender treatment of the subjects are a clear indication of Ramsay's intuitive gift for painting. His compositions are not so much concerned with strategic placing of objects as with the placing of tonal blocks of colour. Black and white pigments often give artists problems but again Ramsay's mastery of paint is displayed by his sensitive handling of these pigments in *The Sisters*.

Ramsay continued to paint in Melbourne until his death in 1906.

Jeanne, 1902
Oil on canvas

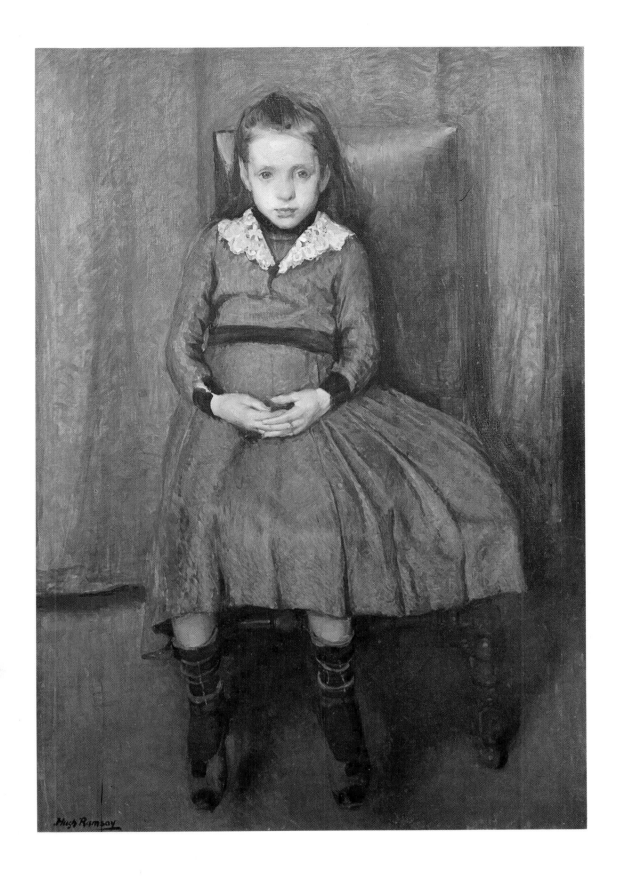

SYD LONG

b. Goulburn 1878; d. England 1955

Sydney Long was born in Goulburn in 1878. In the 1900s he became a pupil of Julian Ashton's at the Sydney Art School. He also studied under Malcolm Osborne in London. During the early twentieth century he was especially popular for his etchings.

His paintings were worked in a number of different styles. Some depicted traditional landscapes in oils. Others reflected a more natural and unpretentious treatment, such as Ashton would have approved of. In still others the influence of Streeton is undeniable but perhaps the most interesting of them all is that of Art Nouveau.

In the 1890s this movement was all the rage in Europe. Long adopted its decorative qualities and its poetic subject matter. His paintings, *Spirit of the Plains* and *Pan* are two examples of how the movement had inspired him, but his real concern lay not with any particular style, but with the way Australian painting up until this time had ignored the true mystical nature of the bush. In 1905 he spoke of Conrad Martens' work as being 'extremely unconvincing from the Australian point of view'. On another occasion he complained that the exhibitions of Australian art did not 'reflect the primitive landscape of the country but bits of seascape, scraps of orchards and blossom that might be anywhere'. He wished to enrich Australia with a mythology in which the Aboriginal would play an heroic but graceful part. Art Nouveau was an appropriate idiom in which to evoke this weird and mysterious spirit. In his desire to abandon nostalgic, colonial perception and to replace it with a 'true' Australian art he was the forerunner of many twentieth-century artists.

In 1938 and again in 1940 Long was awarded the Wynne prize. His work is represented in the print collections of the British and Victoria and Albert Museums in London as well as the Australian State Galleries. He died in London in 1955.

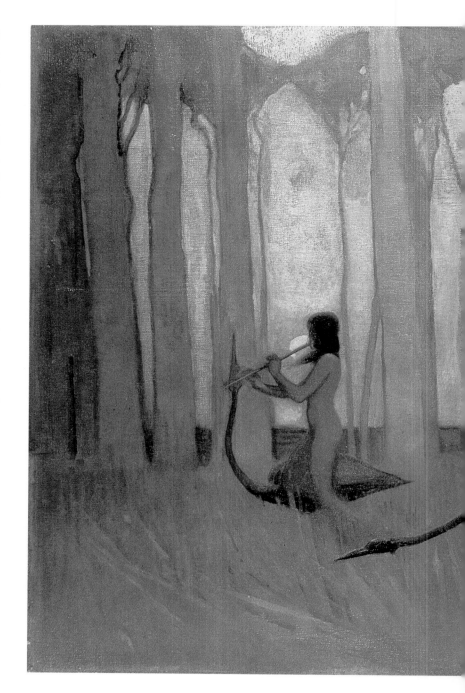

The Spirit of the Plains, 1914
Oil on canvas

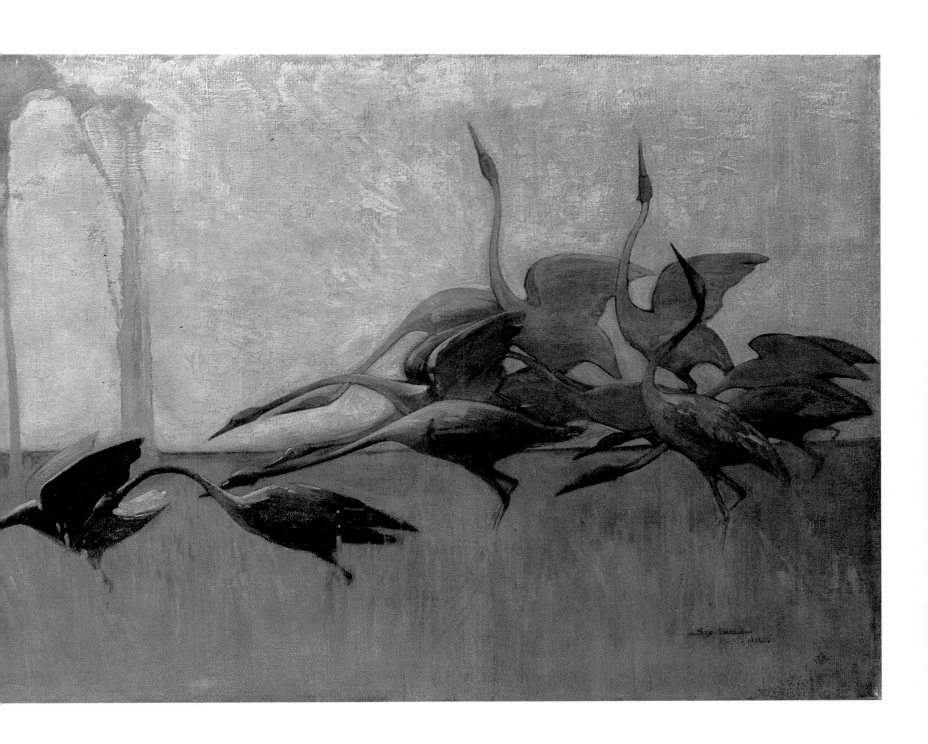

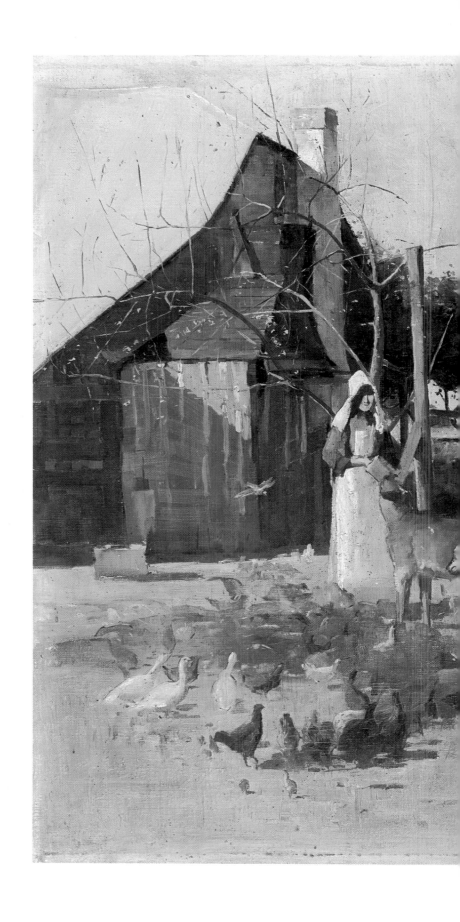

Feeding Chickens at Richmond, c. 1896
Oil on canvas

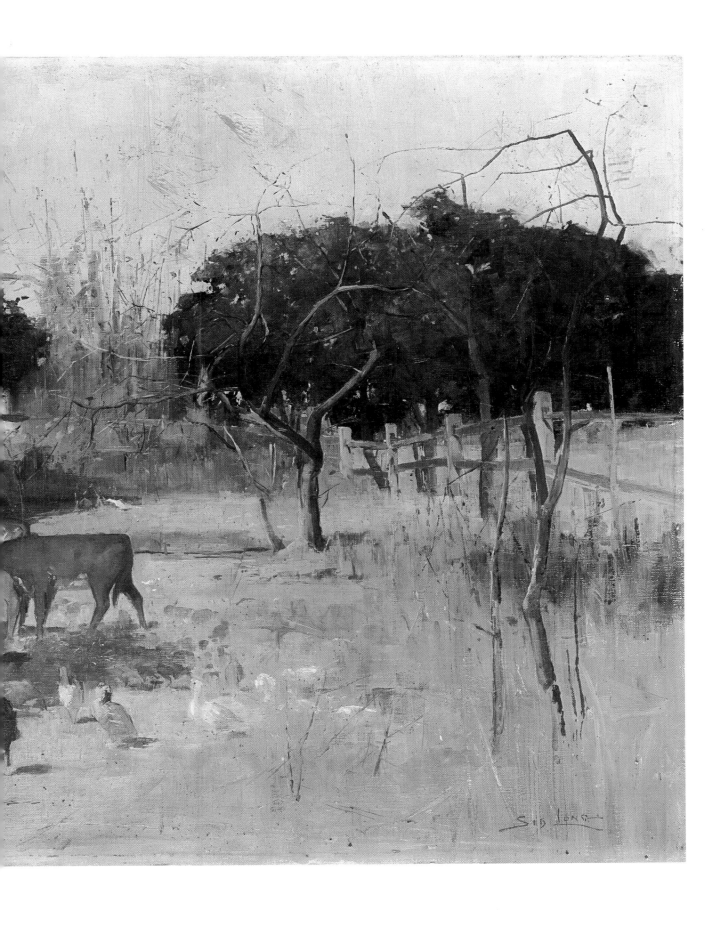

NORMAN LINDSAY

b. Creswick 1879; d. Springwood 1969

Norman Lindsay was the fourth son in a talented family of artists and writers. He was born and educated at Creswick, Victoria and spent the first years of his career as an illustrator for the *Hawklet* in Melbourne.

During his early days in Melbourne, Lindsay led a Bohemian life in company with his brothers and the caricaturist Will Dyson. One of his first ventures was a set of illustrations of the *Decameron* of Boccaccio. As a result of this work Lindsay was given a position with the *Bulletin* and remained with the magazine as chief cartoonist until 1958. As a pen-draughtsman and etcher Lindsay became the most celebrated black-and-white illustrator of his time.

Lindsay's work was frequently controversial and his work earned the censure of various religious organisations and moralists. The uninhibited nature of his work in *Art in Australia* became the target of an unsuccessful police prosecution but the eroticism in Lindsay's work was largely overlooked in official quarters.

Lindsay illustrated some of the Roman and Greek classics and works of Rabelais and Casanova. He travelled widely in Europe and while in the United States worked as an illustrator for a number of leading magazines. Lindsay had achieved great popular fame by the 1920s when he was seen as a Renaissance man — painter, writer, sculptor, landscape designer, maker of ship models, etcher, newspaper cartoonist and book illustrator.

Lindsay's books include *A Curate in Bohemia* (1913), *Age of Consent* (1938) and the phenomenally successful *The Magic Pudding* (1918) which has become a children's classic.

Large collections of his work are housed at the University of Melbourne and in his former home at Springwood, New South Wales, under the care of the National Trust. Lindsay died at Springwood in 1969 and left three sons who were also prominent artists and writers.

Where War Ends, 1924
Watercolour

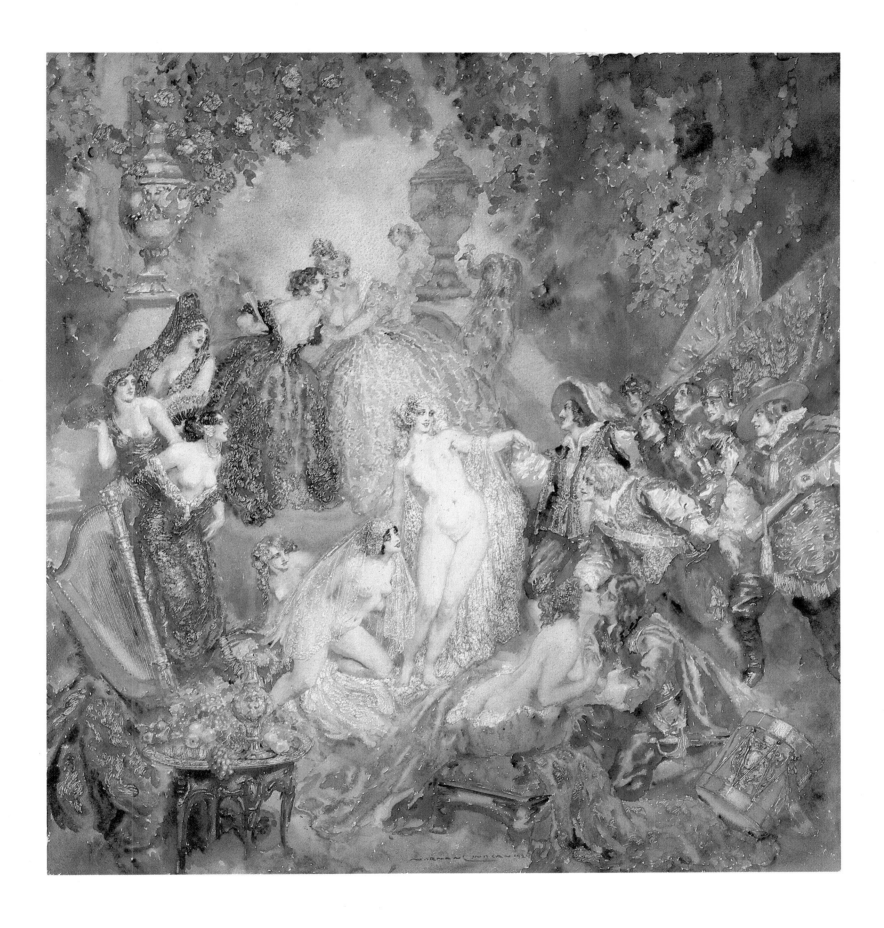

ELIOTH GRUNER

b. New Zealand 1882; d. Sydney 1939

A landscape painter who was often called the last of the Australian Impressionists, Elioth Gruner was born in New Zealand of Norwegian-Irish parentage and brought to Australia as a child.

Gruner's early interest in the play of light on landscape was demonstrated in his small work *Morning Light* (1915) and the larger *Spring Frost* which are now both in the Art Gallery of New South Wales.

Gruner travelled to Europe in 1923 and whilst in London arranged the exhibition of Australian art sponsored through the Society of Artists for showing at the Royal Academy.

After his return to Australia, Gruner painted more expansive landscapes such as *Spring at Bathurst* and *Belligen Pastoral*. His largest work, *The Valley of the Tweed*, commissioned by the trustees of the Art Gallery of New South Wales, was painted over four months in the open air and with it he won the Wynne Prize in 1921. Gruner won this award a total of seven times from 1916 to 1937.

Gruner was a leading member of the Australian Art Association and the New South Wales Society of Artists. He died in Sydney in 1939.

Spring at Bathurst, c. 1934-35
Oil on canvas

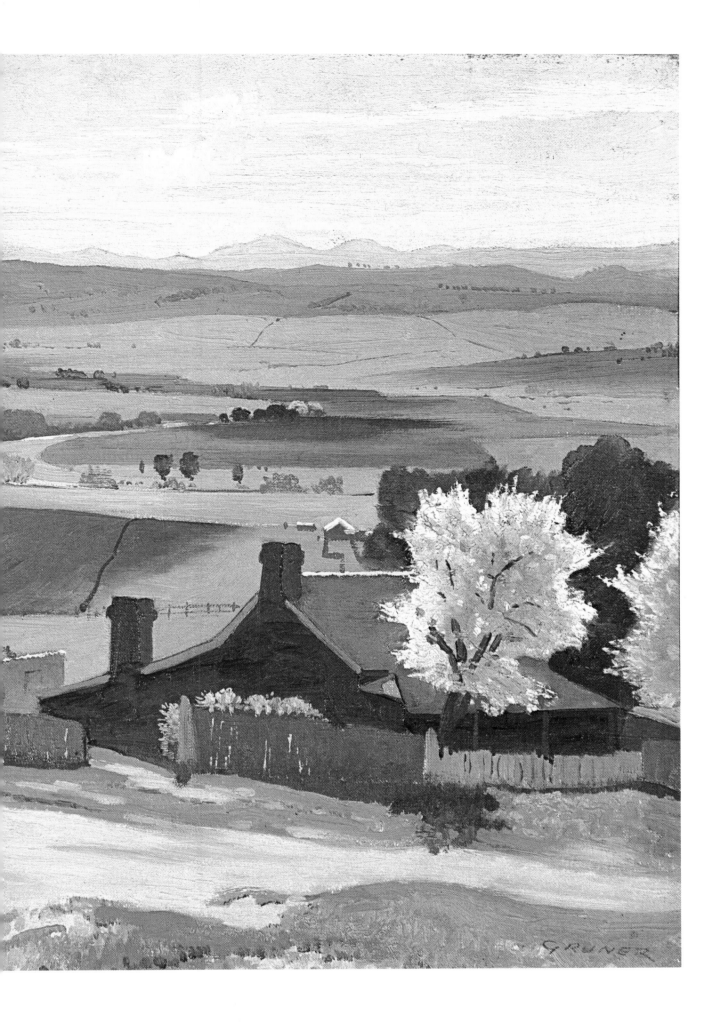

ROLAND WAKELIN

b. New Zealand 1887; d. Sydney 1971

Roland Wakelin, born in New Zealand in 1887, emigrated to Sydney in 1912 and enrolled in the Royal Art Society School the following year. He studied under Dattilo Rubbo who, while not directly influencing him, opened his eyes to new possibilities. With Roy de Maistre and Grace Cossington Smith, he founded the neo-Impressionist movement.

Tradition held little appeal for Wakelin and he experimented widely with both colour and form — experiments which owed much to the works of Cézanne, Gaugin and Van Gogh. A collaboration with Roy de Maistre in 1919, based on de Maistre's theory on colour and music, brought harsh criticism. It was not until the 1930s that Wakelin gained wide acceptance, as he developed a more mature, richer style.

During the 1950s Wakelin devoted much of his time to teaching, particularly in the University of Sydney's School of Architecture. He won various awards before his death in 1971.

Down the Hills to Berry's Bay, 1916
Oil on canvas mounted on hardboard

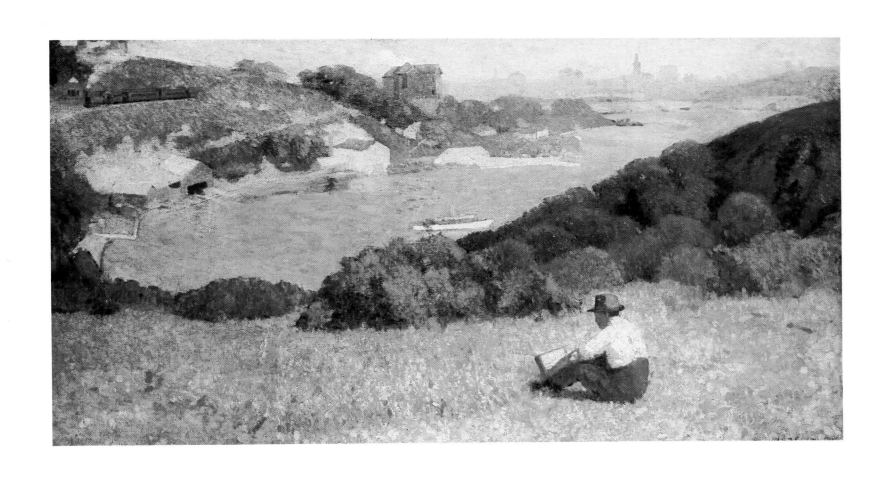

Bridge Under Construction, c. 1928-29
Oil on canvas on board

100

IAN FAIRWEATHER

b. Scotland 1891; d. Brisbane 1974

An artist of exceptional force and originality, Fairweather is regarded as the least parochial of modern Australian painters.

Born in Scotland in 1891, one of nine children of an army surgeon, Fairweather spent the first 62 years of his life in restless, often frenzied wanderings; he seemed unable to settle in one place for any length of time.

He was taken prisoner on the second day of World War I and spent the next four years in German camps — where he began to sketch and paint. In 1929 he sailed to China and began a life-long romance with the Orient. For a while he lived in Shanghai and did some of his best paintings there — *Chinese Mountain, Bridge in Peking, Hangchow* and *Canal Scene.*

He first came to Australia in 1934 and, despite an enthusiastic welcome from Melbourne's artist colony, couldn't settle; by December he was off to the Philippines, then back to China again.

In Peking he almost starved to death; as a hobo he was thrown off trams. Often he didn't have any money for paints but somehow managed to produce more paintings and sent them down to Australia to friendly patrons and galleries.

In April 1936 he left China, never to return again to that country where, despite his awesome poverty, he spent some happy and productive years. After the usual stopovers, in 1938 he arrived in Brisbane and a few months later in Cairns — with a pound in his pocket. He stayed outside Cairns at Alligator Creek, in a primitive boathouse, sharing the life of other outcasts — Aboriginals, Malays and Islanders.

In 1939 Fairweather did most of his paintings in oil; after that, because of an allergy, he switched to gouache. In 1940, when war broke out, driven by restlessness rather than military fervour, he travelled to Singapore and then to India where the British Army employed him on a make-do job. By 1943, however, he was back in Melbourne continuing his almost untraceable travels.

In 1953, almost by accident, he stumbled on Bribie Island, in Queensland — and apart from a few erratic trips, stayed there for the rest of his life. He kept sending his paintings to galleries in Melbourne, Sydney and London; his reputation as an artist grew — but Fairweather still lived like a primitive hermit, in a shack without water, electricity or sewer.

Fairweather came to art late in life; he was 45 before his first, one-man exhibition. He experimented with Post-Impressionism, Futurism and Cubism — all well after these trends had declined.

His years of sustained brilliance again came late in life, in the 1957-63 period, after he switched from gouache to plastic paint. *Last Supper, Kite Flying, Flight to Egypt, Mangrove, Monsoon* and other works were born — all now rated among his best.

In 1966 he suddenly flew to London, feeling slightly homesick, but didn't stay long and escaped back to his beloved Bribie Island. Gradually, however, old age, a variety of illnesses and arthritis slowed him down; in 1972 he stopped painting and spent most of his days reading or watching the silent bush.

Fairweather died on May 20, 1974 in Brisbane.

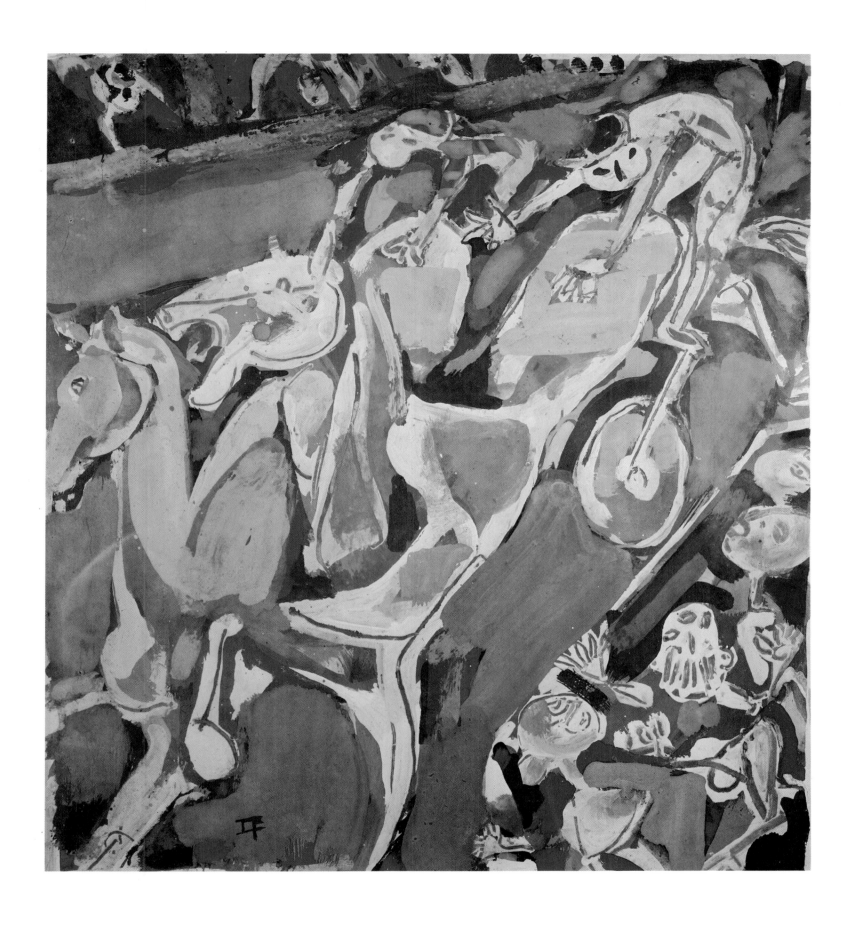

Trotting Race, c. 1956
Gouache on cardboard

Turtle and Temple Gong, 1965
Synthetic polymer paint and gouache on cardboard

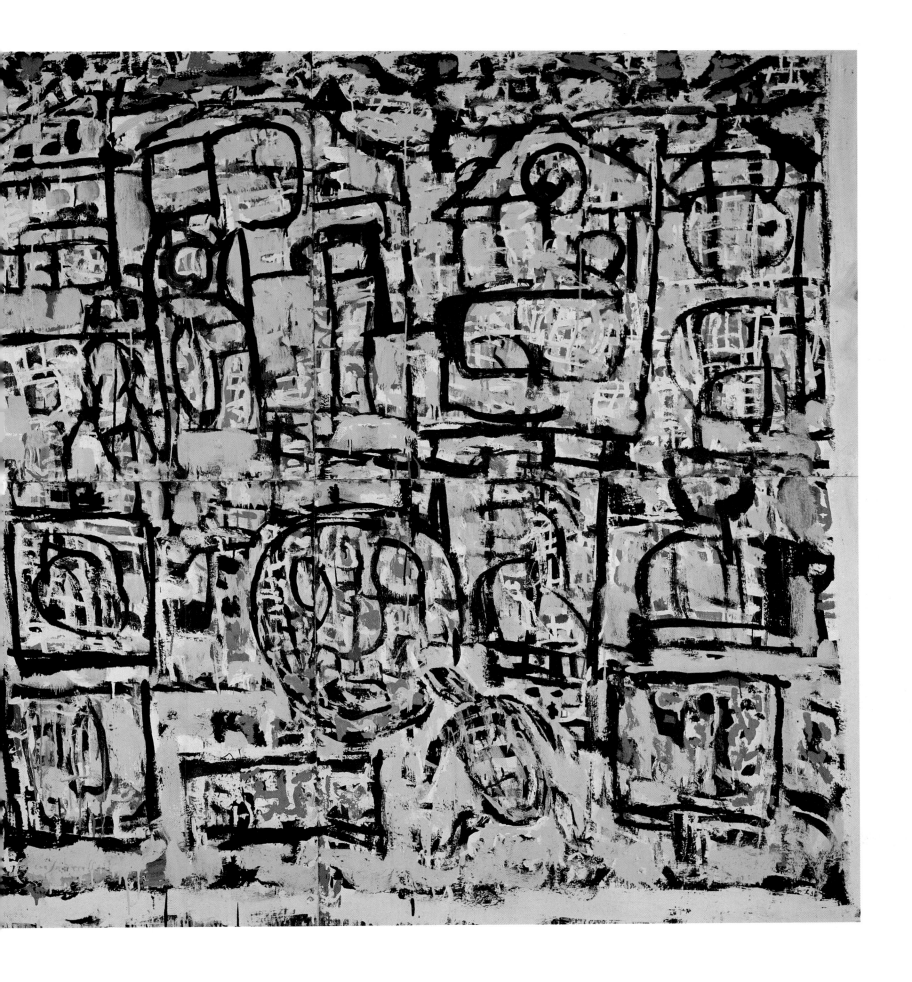

105

GRACE
COSSINGTON SMITH

b. Sydney 1892

One of the leaders of the neo-Impressionist movement, together with Roland Wakelin and Roy de Maistre, Grace Cossington Smith was born in Sydney in 1982. She spent two years studying at Dattilo Rubbo's studio before leaving for Europe, where she continued at the Winchester Art School, England, and in Germany.

Like others of the neo-Impressionist movement, she was slow to gain public recognition. Her first major exhibition was in 1928, but it was not until the 1960s that her works were sought after.

Despite her seeming lack of success with critics and the public, Cossington Smith's works were exhibited quite extensively. The Macquarie Galleries in Sydney hosted a number of her works for many years. She also held exhibitions in several important English galleries between 1930 and 1950. The Australian State galleries hold many of her most significant works.

The Sock Knitter, 1915
Oil on canvas

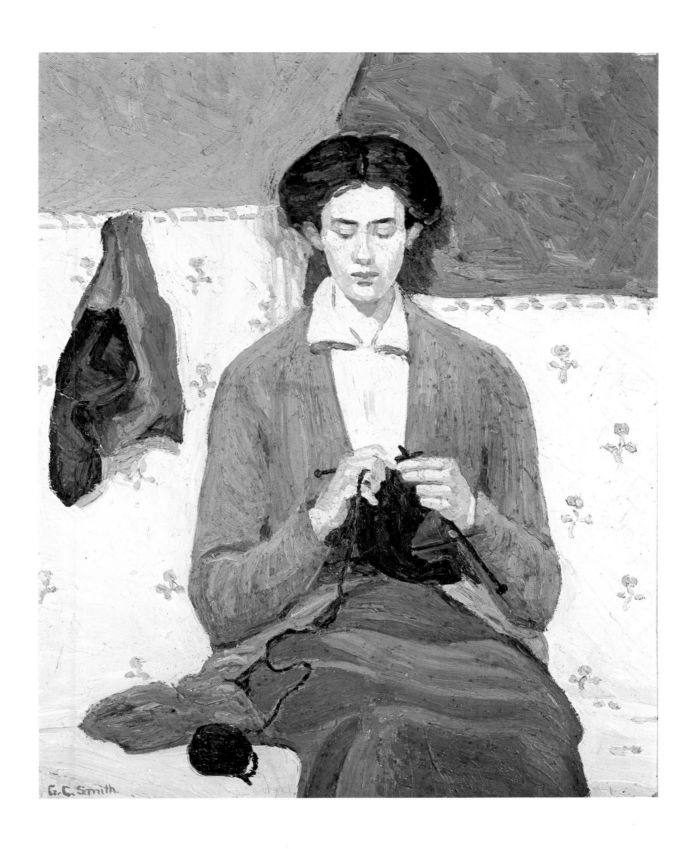

GODFREY MILLER

b. New Zealand 1893; d. Sydney 1964

Born in New Zealand in 1893, Miller was a graduate architect before, in 1929, he went to London to study painting; this, full-time and part-time, took up almost 10 years of his life.

Earlier he was wounded at Gallipoli, then travelled extensively in Hong Kong, Japan, Egypt and Europe. He arrived in Australia in 1939 and lived at Warrandyte, Victoria, being totally absorbed in the Australian bush. In 1954 he moved to Paddington, Sydney's art-conscious suburb and died there 10 years later.

He created some extraordinary paintings, both intellectual and sensuous, strict and wayward at the same time. His paintings hang in most State galleries as well as the famed Tate Gallery in London.

Nude and the Moon, 1954–58
Oil on canvas

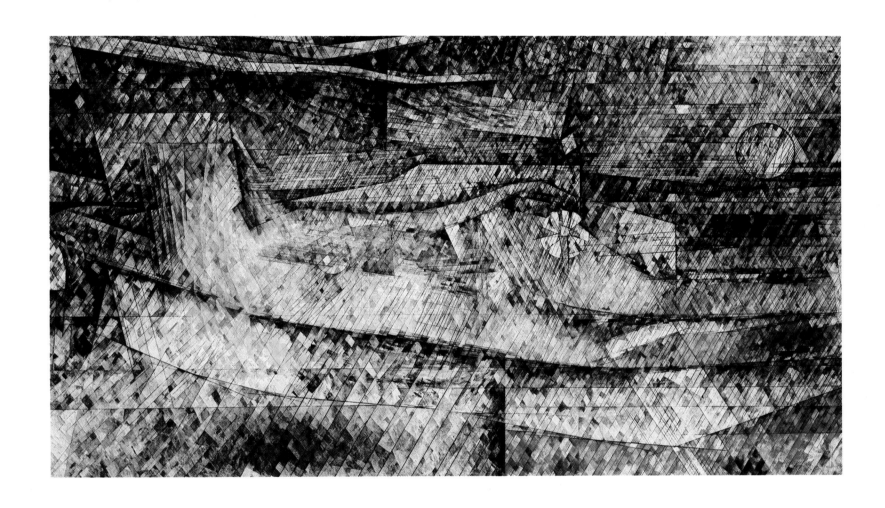

Building and Trees, 1951–53
Oil on canvas

LLOYD REES

b. Brisbane 1895

One of the grand old men of Australian art, Rees was born in 1895 in Brisbane, and graduated as an architect at the Chelsea Polytechnic in 1923.

As a painter, his first major success came in 1937 when he won the silver medal at the Paris Exposition. After the war many more prizes and distinctions followed, including the Commonwealth Jubilee Prize of 1951.

Rees is a neo-Romantic painter whose works are full of suggestions, associations and veiled meanings. At the peak of his active career, he was regarded as the idol of painters of the younger and middle age generations, such as Brett Whiteley.

He spent most of his adult life in Sydney where he studied the foreshores of Sydney Harbour with the same care as Conrad Martens; *The Harbour from McMahon's Point* won him the 1950 Wynne Prize for landscape painting.

The Olgas — The Northern Aspect, 1976
Oil, crayon and watercolour with pencil

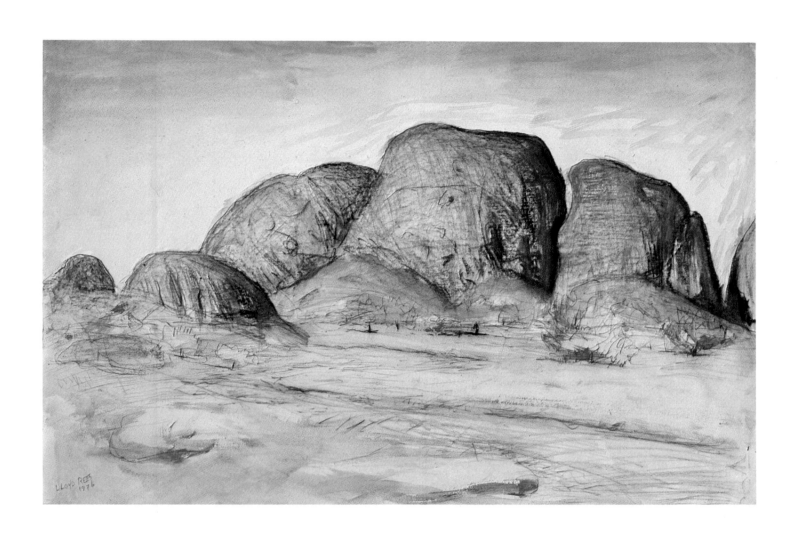

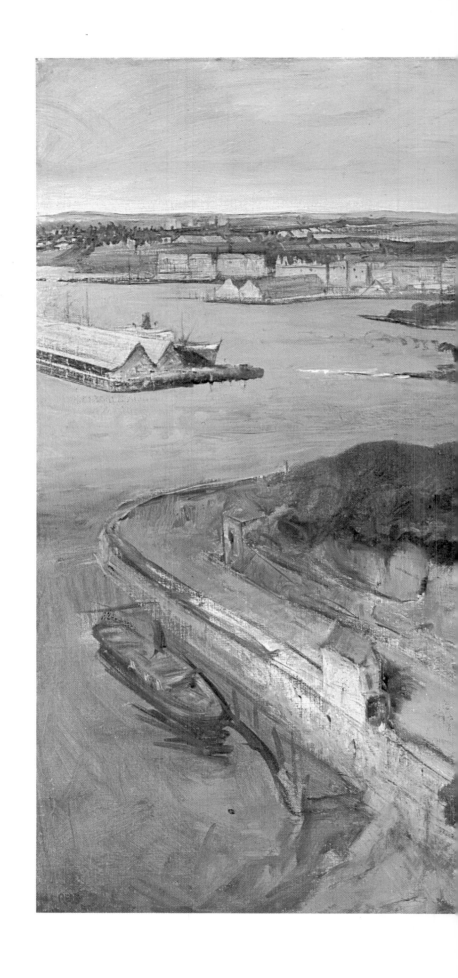

The Harbour from McMahon's Point, 1950
Oil on canvas

114

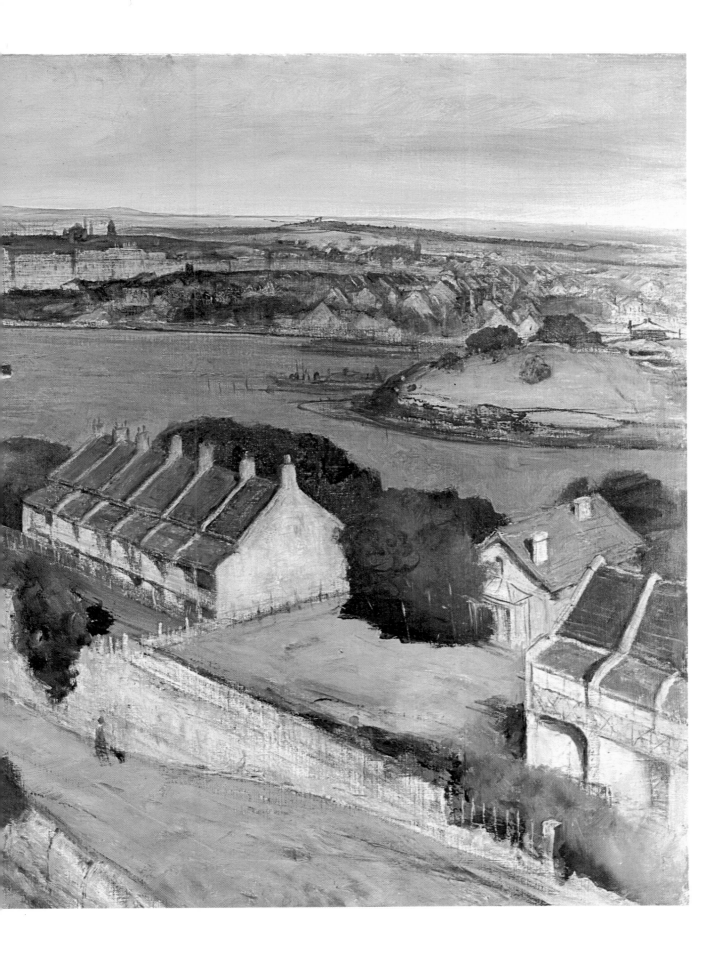

SALI HERMAN

b. Switzerland 1898

One of the numerous foreign-born Australian painters to achieve a high level of distinction, Herman was among the first to 'Discover' Paddington, Woolloomooloo and Glebe in his paintings.

Born in Zurich, Switzerland in 1898, Herman arrived in Australia in 1937 and, a year later, settled in Sydney where he quickly became best known for his paintings of street scenes and worn, old buildings. His *Law Courts* and *Near the Docks*, are typical of his street scenes.

He won many major prizes: the Wynne in 1944, 1963 and 1965, the Sulman in 1946 and 1948 and others. He is represented in all State art galleries and the Australian War Memorial: in 1945-46, Herman was appointed an official 'war artist'.

Near the Docks, 1949
Oil on canvas, mounted on board 1970

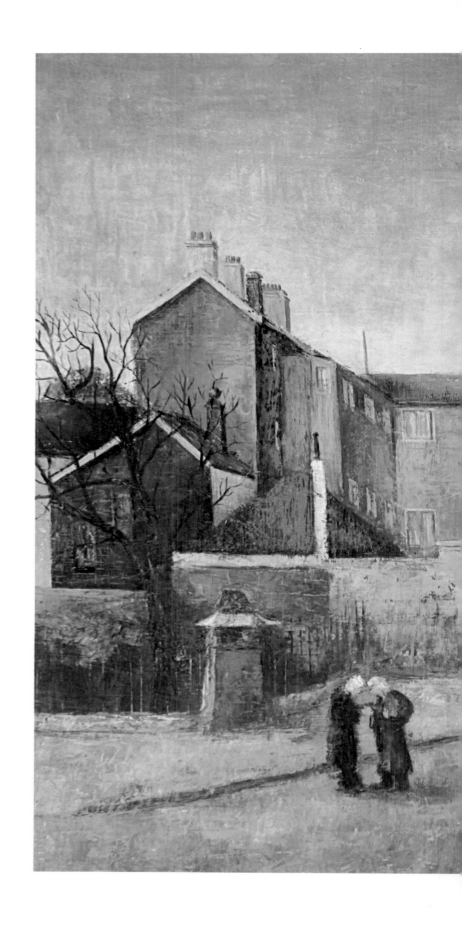

The Law Courts, 1946
Oil on canvas

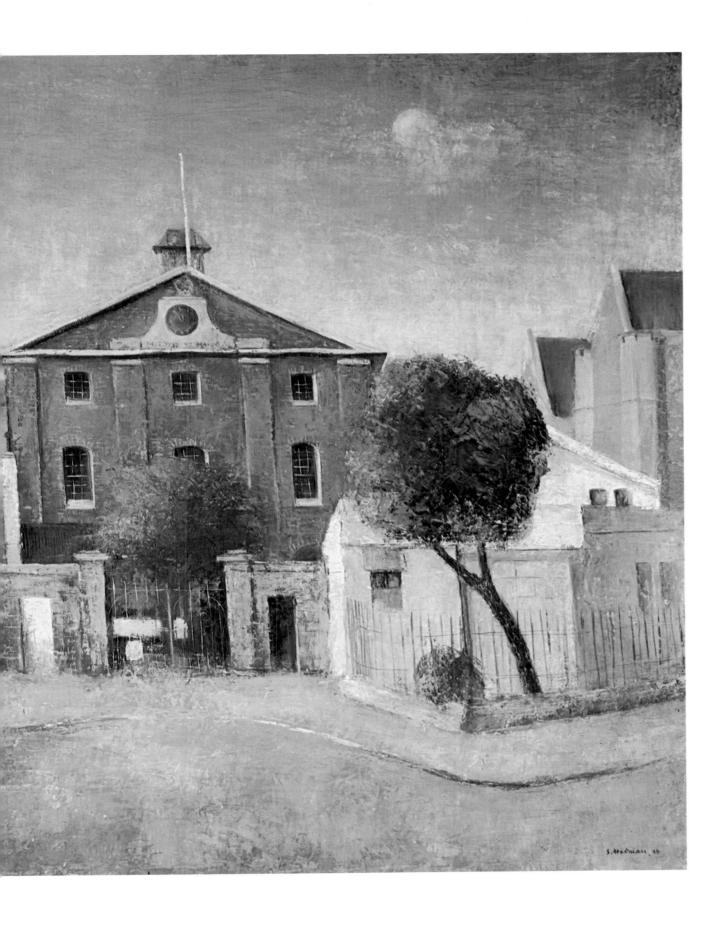

WILLIAM DOBELL

b. Newcastle 1899; d. Wangi Wangi 1970

One of Australia's most celebrated landscape and portrait artists, William Dobell was born in Newcastle, New South Wales on 24 September 1899 and received his early education at a local primary school.

Upon leaving school he took a variety of jobs before becoming apprenticed to a Newcastle architect. In 1923 Dobell moved to Sydney and studied at the famous Julian Ashton Art School and in 1929 won the Society of Artists travelling scholarship which enabled him to study at the Slade School, London. He also studied for a short time in Holland, France and Belgium and held several exhibitions in London including one at the Royal Academy in 1933.

When his scholarship funds ran out, Dobell remained in London and supported himself by working as a magazine illustrator and film extra. Many critics consider his work during those years which included *The Dead Landlord* among some of his best.

It was during this period that Dobell firmly established himself as an important portrait painter with works including *The Cypriot*, *The Strapper* and the controversial *Joshua Smith* which won the 1943 Archibald Prize, Australia's most prestigious award for portraiture. However, the decision was challenged by two artists who claimed Dobell's work was a caricature rather than a portrait. A bitter court case ensued which eventually ruled in Dobell's favour but the acrimony and rancour left an indelible mark on the sensitive Dobell and his health suffered; even his ability to paint was impaired for a time. However, the wide publicity did more than any other single event to focus public attention on the work of contemporary artists.

When Dobell once again won the Archibald Prize in 1948 with a portrait of *Margaret Olley* his work was vindicated and his position as Australia's foremost portrait painter firmly established. In that same year Dobell won the Wynne Prize for *Storm Approaching Wangi*.

Dobell won his third Archibald Prize in 1959 with a portrait of his surgeon Dr. E. MacMahon. During the 1960s he was commissioned by *Time* magazine for a cover portrait of Prime Minister Robert Gordon Menzies and was subsequently asked to do three more cover portraits for the magazine.

In 1960 William Dobell was awarded the Society of Artists Medal and in 1964 won the Britannica Australia Award for Art. In the same year when the Art Gallery of New South Wales held a retrospective exhibition of his works, paintings from all periods were brought to Sydney from all parts of the world.

In his later years Dobell lived in a cottage at Wangi Wangi on the shores of Lake Macquarie, New South Wales where he continued to paint until his death.

His later paintings such as *The Opera House* (1968), *Kindly Man* and his self portrait, took on a white, whispy appearance of mystical vitality. Although Dobell caressed the canvas in sweet, slender strokes, the forms were rounded and full as though he were tracing them with his fingers.

Dobell was appointed an OBE in 1965 and was knighted in 1966. Under the terms of his will the William Dobell Art Foundation was established to benefit and promote art in New South Wales. He died at Wangi Wangi on 14 May 1970.

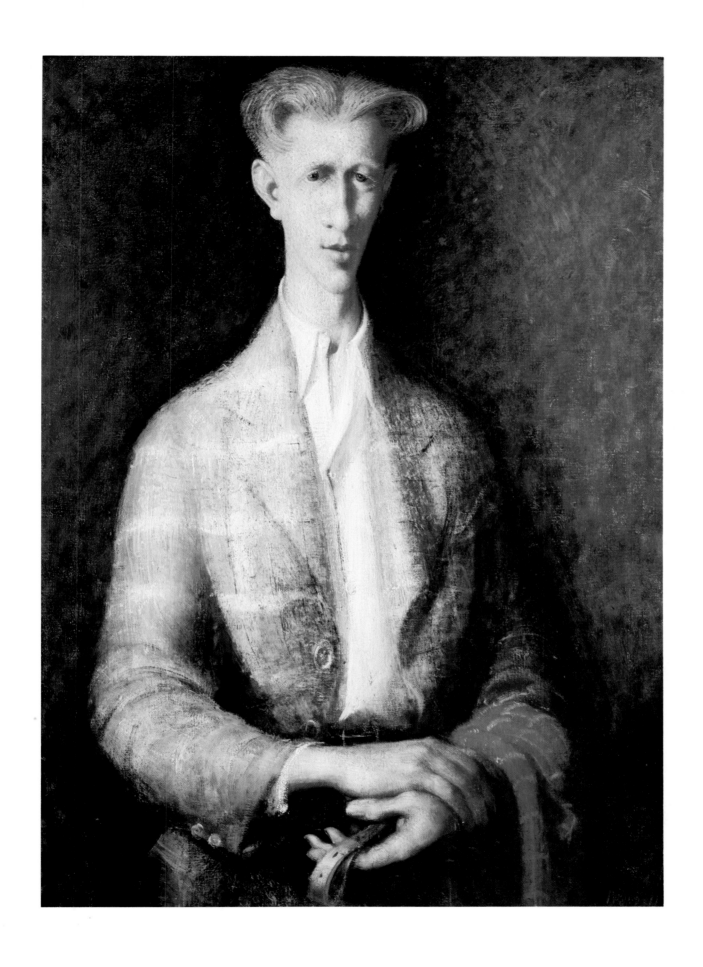

The Strapper, 1941. Oil on canvas.

The Opera House (second version, unfinished), 1968.
Oil on hardboard.

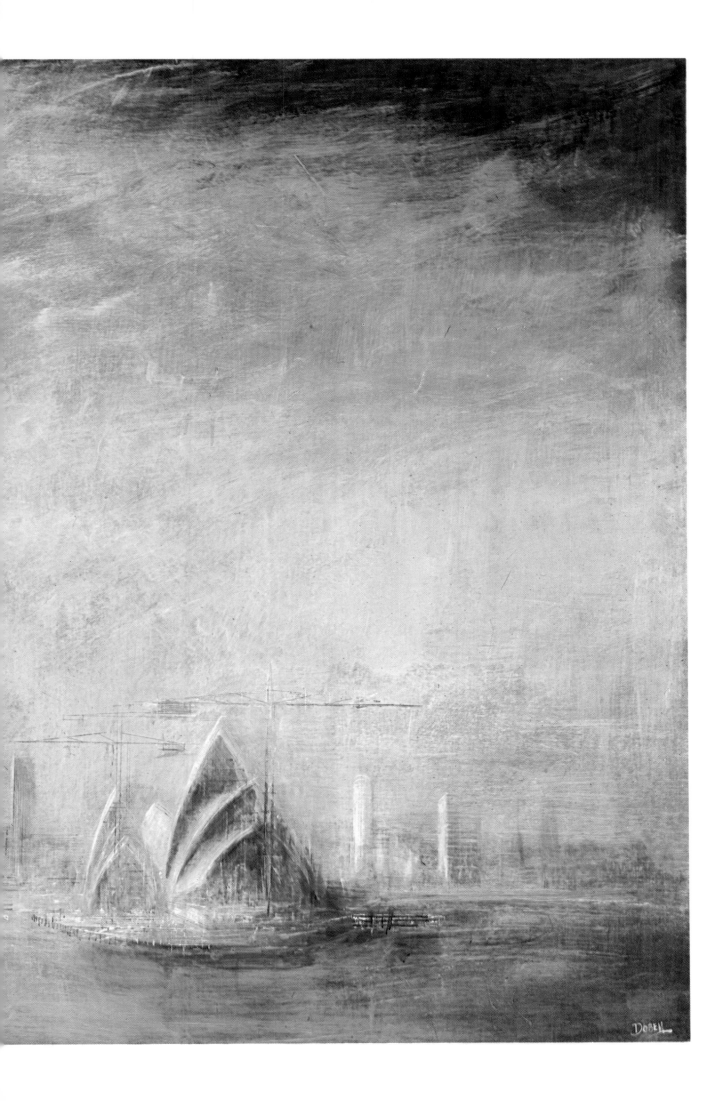

123

RUSSELL DRYSDALE

b. England 1912; d. Sydney 1981

Drysdale was born at Bognor Regis, England in 1912. His family moved to Australia when he was 11. He was a boarder at Geelong Grammar while his family settled first in Melbourne, then later on a property, Boxwood Park, in New South Wales. In 1929 Drysdale left school and went to Boxwood Park; he had started to develop eye trouble. This was diagnosed as a detached retina of the left eye. Drysdale had always shown talent in school for drawing both sketches and caricatures, and it was this hobby that kept him amused during his recovery from an operation in 1932.

In 1935 Drysdale married Elizabeth 'Bon' Stephen, the sister of a school friend. Soon, after an unsuccessful operation on his eye, he made a serious attempt at art by enrolling at the Shore-Bell art school.

Drysdale started by drawing, usually using red chalk. Later he drew using pen, an art form which demands acute observation qualities. In 1938 his daughter, Lynne, was born and the first of his one-man exhibitions was held.

Many of his paintings have the appearance of people posing, when actually he painted from memory rather than models. The *Drover's Wife* and *Sunday Evening* are perfect examples of this.

Drysdale was often called lazy. He would only work when the mood took him or when the deadline for an exhibition was nearly upon him. He rested for long periods, building up his store of impressions. However, when Drysdale worked, he worked hard.

The Drysdales travelled extensively, both overseas and within Australia. In 1944, he travelled throughout the drought areas; this resulted in his series of paintings with a drought theme.

Unlike many artists, Drysdale was recognised for his work during his own lifetime. He received many awards and decorations and in 1969 he was knighted.

In his private life, he endured many tragedies. In 1962 his son, Tim, committed suicide and this was followed in 1963 by his wife also committing suicide. He remarried in 1964, to Maisie Purves-Smith. In 1974 and 1975 he underwent two surgeries and in 1980 he suffered a stroke.

Although Drysdale is renowned for his painting, he was also a highly accomplished photographer and just before his death, he did his first series of etchings to illustrate a book of Henry Lawson stories. The etchings and the stories complemented each other perfectly.

Drysdale died in 1981.

Man Feeding his Dogs, 1941
Oil on canvas

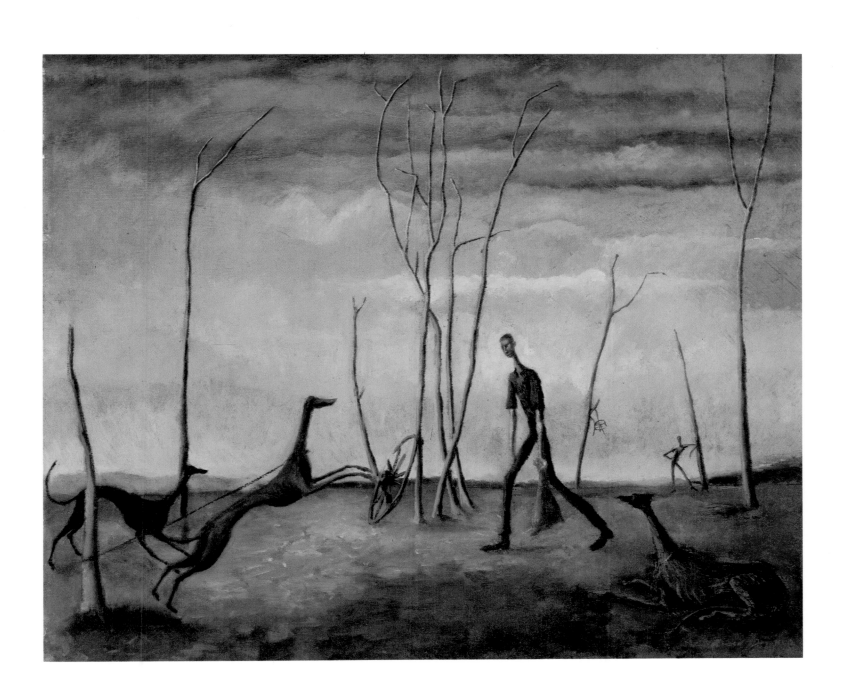

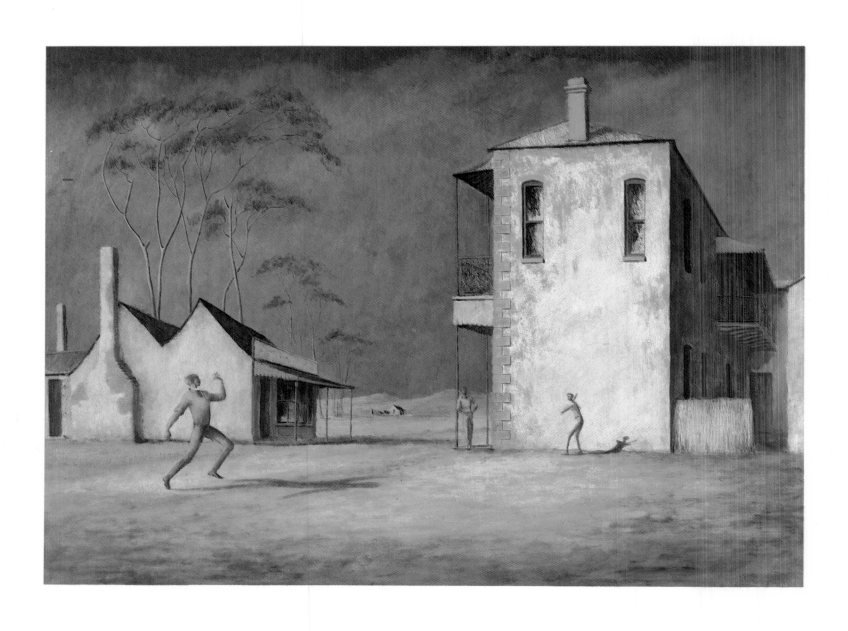

The Cricketers, 1948
Oil on masonite

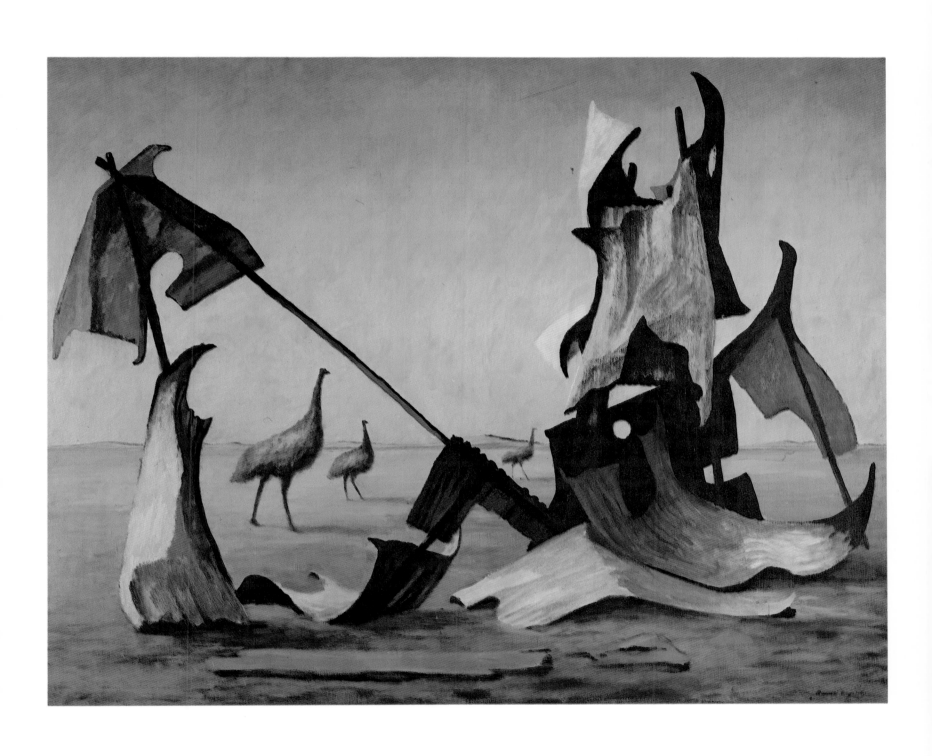

Emus in a Landscape, 1950
Oil on canvas

ALBERT TUCKER

b. Melbourne 1914

Another Australian artist who felt the need to spend long years overseas to develop his style.

Tucker was born in 1914 in Melbourne and was self-taught in the art of painting. His paintings first attracted attention during the depression years when he worked as a freelance illustrator, painter and writer. He became a pioneer of modern expressionists and surrealists, coming into sharp conflict with the prevailing conservative tastes.

At the end of 1947 he travelled to Europe where he was to spend 11 years, before going to the United States. He held one-man exhibitions in Amsterdam, Paris, Rome, London and New York. In 1960 a Melbourne museum provided funds for his return to Australia after which he held a number of highly successful exhibitions here. Apart from the various Australian State galleries, Tucker's works are also represented in the famous Museum of Modern Art and the Guggenheim, both in New York.

Night Image, 1945
Oil on plywood

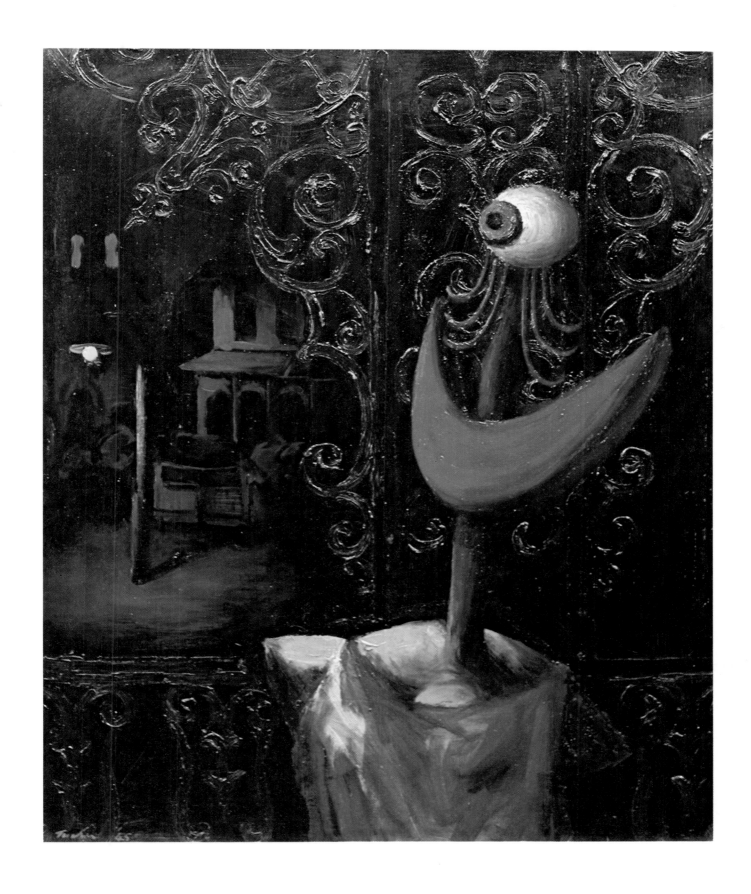

JAMES GLEESON

b. Sydney 1915

Most would know him better as an art critic and writer; since 1949 he has been working for various Sydney newspapers and magazines, writing about other artists and exhibitions.

Born in 1915 in Sydney, Gleeson had his first paintings hung at the Contemporary Art Society exhibition in 1938, in Melbourne. He painted surrealist pictures which began with Dali-like images and became more abstract as he matured. From 1963 he painted a series of very small, figurative, surrealist pictures based on Greek legends. In the 1960s he travelled extensively in Europe, the Orient and the United States.

We Inhabit the Corrosive Littoral of Habit, 1940
Oil on canvas

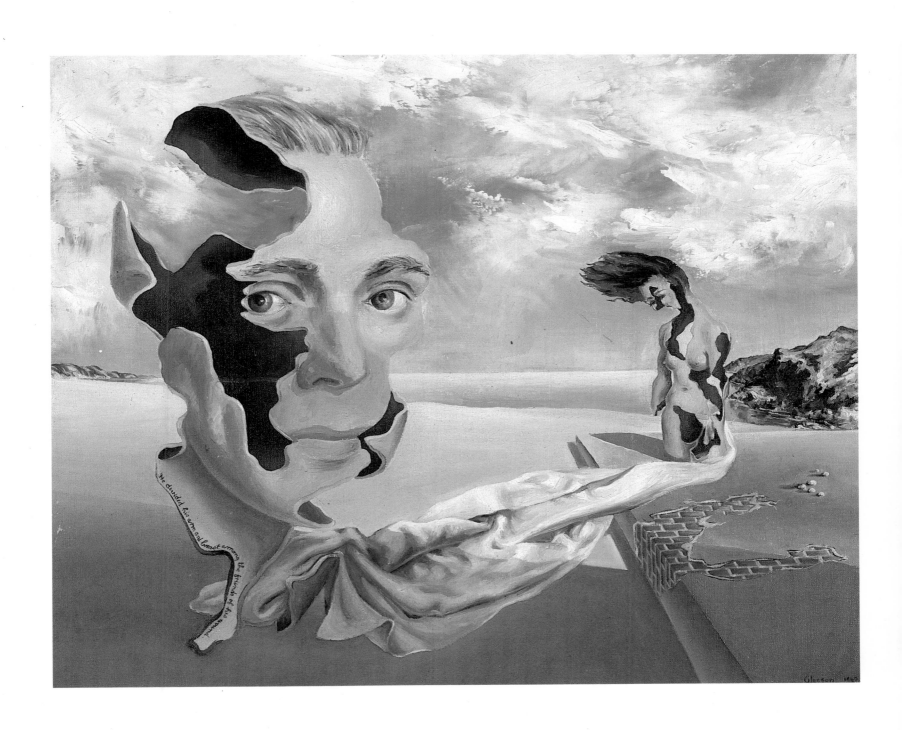

DONALD FRIEND

b. Sydney 1915

An internationally recognised artist who is perhaps best known for his paintings of Eastern life and culture, especially village life on the island of Bali, Donald Friend was born in Sydney in 1915.

He studied at the Royal Art Society School and the Westminster School in London before living and working in Nigeria in the late 1930s. Back in Sydney in 1940, Friend's paintings became known for their wit and versatility. He served with the AIF during the war and wrote and illustrated two books on his experiences, the *Gunner's Diary* (1943) and the *Painter's Journal* (1946).

From 1949 to 1955 Friend travelled widely and lived in Italy, the Torres Strait Islands and Ceylon. In 1956 he created one of his best works, *The Fortune Teller*. From 1967 to 1978 Friend lived on the island of Bali but held regular exhibitions of his work in Sydney and Paris. During these years he produced one of his acclaimed paintings *Birds and Insects in a Landscape* (1969).

In 1979 Friend moved to Melbourne and in 1981 settled permanently in Sydney. Some of his awards include the Flotta Lauro Prize (1951), the Blake Prize for Religious Art (1955) and the Bunbury Prize (1962). His work is represented in the Australian National Gallery, in State and provincial galleries and in many private collections in Australia and overseas.

Friend's publications include *Hillendiana* (1956), *Save Me from the Shark* (1972), *The Cosmic Turtle* (1976) and *Birds from the Magic Mountain* (1977).

Brisbane River, 1944.
Tinted pen and wash drawing with watercolour on paper.

SIDNEY NOLAN

b. Melbourne 1917

Creator of the famous Ned Kelly paintings and Australia's best known painter internationally, Sidney Nolan was born in the Melbourne suburb of Carlton on 22 April 1917.

After completing school and a part-time course at the Prahran Technical School, Nolan's first creative efforts were directed towards advertisements and displays in a men's hat factory.

During the war, Nolan's stint in the Australian army, when he was sent to the Wimmera district of Victoria, played an important part in his artistic development. It was here that he first experienced 'inland' landscapes and painted a number of works which vividly captured the shimmering gold of the wheatfields.

These paintings were the first Nolans to find public acceptance but it was his *Ned Kelly* series, painted after his discharge from the army in 1945 that won Nolan major recognition. This series which retraced the siege at Glenrowan, Kelly's capture and hanging, comprised 24 major works including *The Death of Constable Scanlon* which has become a popular reproduction. A second Kelly series was painted in 1954-55.

Around this time Nolan also painted a series of 60 miniatures on glass entitled *Eureka Stockade*. These were first executed in Indian ink and then painted over in ripolin enamel. The effect was translucent and incandescent, rather like Victorian table lamps.

In 1949 after a visit to central Australia and Queensland, Nolan produced his *Burke and Wills* series and a number of panoramic views of the Centre. In these dramatic oils, Nolan portrays what he sees as the true Australia — 'cruel, harsh and barren beyond any other part of the habitable globe.'

In 1949 an exhibition of his work was arranged at UNESCO headquarters in Paris and in the same year Nolan moved to London and travelled extensively in Europe until 1951. Back in Australia, he was commissioned to do a series of drawings on the Northern Territory's drought for the Brisbane Courier Mail. His 'drought' works were widely acclaimed at successful exhibitions in Sydney and Melbourne in 1953.

A retrospective exhibition of Nolan's work was held in London in 1957 which firmly established his international success. Nolan also received enormous critical acclaim for a magnificent tableau which he created for a production of Stravinsky's *Rite of Spring* at Covent Garden, London in 1962.

In the 1970s Nolan once again returned to his homeland and captured the wild beauty of central Australia with works entitled *Ayers Rock and Olgas, Woman and Rock* and *Olgas with Sandhills*, all painted in 1978. In later years Nolan turned his skills again to stage design and fulfilled commissions for the Royal Opera at Covent Garden and designed the Australian Opera's 1983 production of *Il Trovatore*.

Nolan has been the recipient of many important art prizes and honorary doctorates. His paintings are housed in all Australian State galleries, the Australian National Gallery in Canberra which displays 16 of his *Ned Kelly* works, the Tate Gallery in London and the Museum of Modern Art in New York.

In 1974 he donated 100 of his paintings to the Australian people. He was knighted in 1981.

Nowadays Sidney Nolan is based in London but spends a great deal of time at his property near the Shoalhaven River on the south coast of New South Wales.

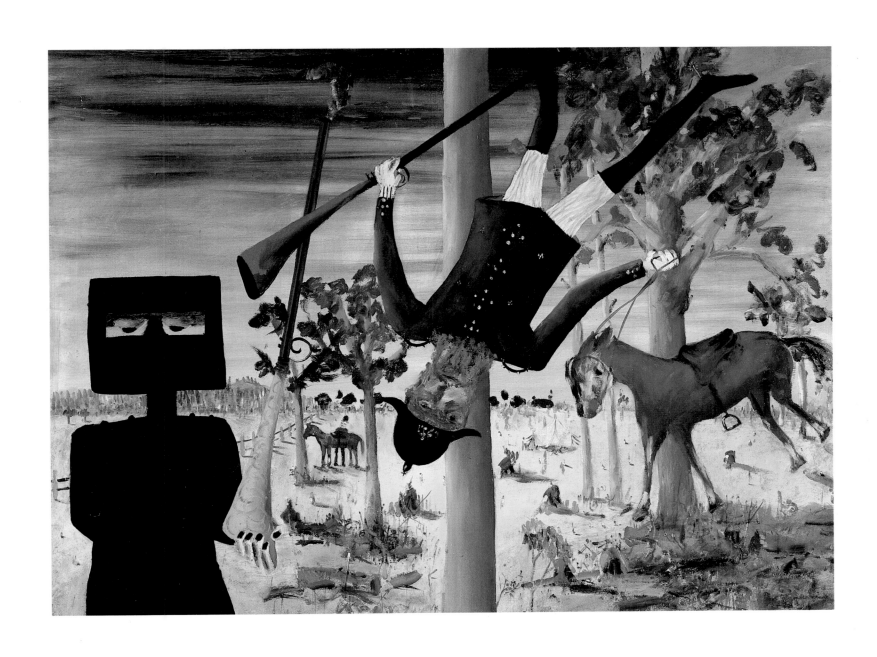

Death of Constable Scanlon, 1954.
Oil on hardboard.

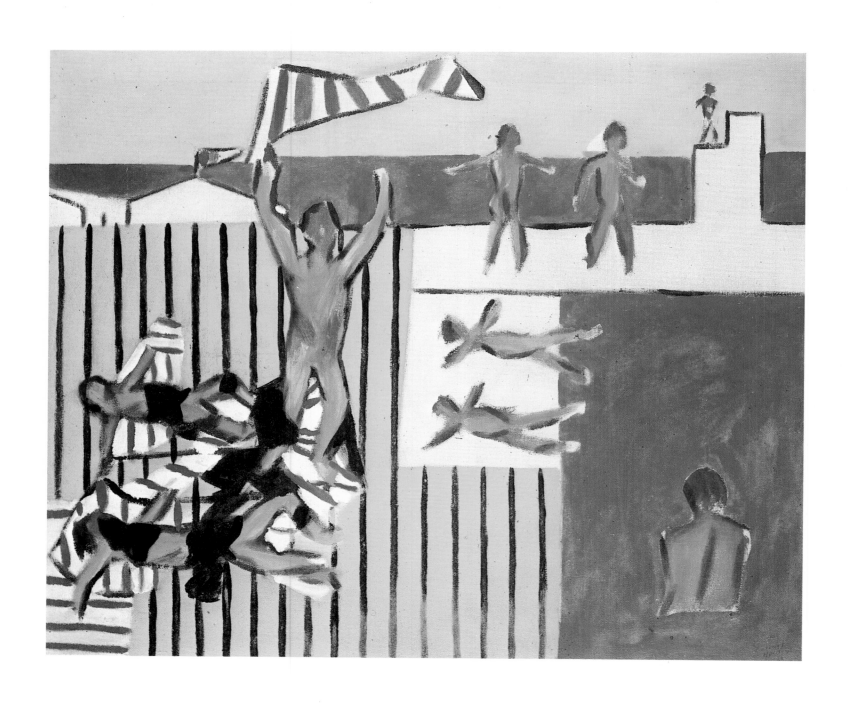

The Bathers, 1945.
Ripolin on hardboard.

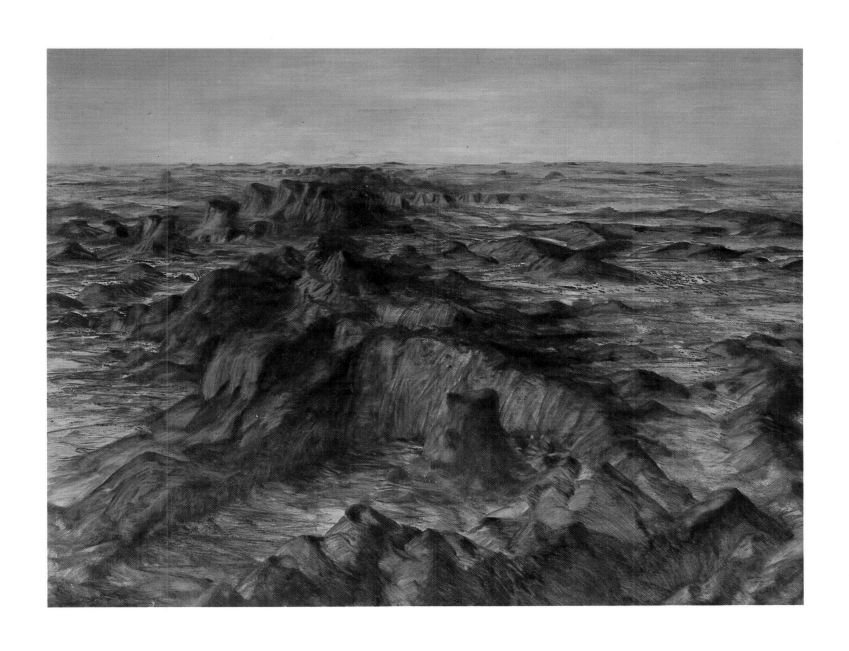

Durack Range, 1950.
Oil on composition board.

JOY HESTER

b. 1920; d. Victoria 1960

Without any formal training, she became one of this country's foremost influential graphic artists. Born in 1920, Joy Hester's work is full of dramatic feelings, largely due to some personal tragedies in her life.

She was first married to Albert Tucker, then to Gray Smith, both eminent painters. She died in 1960 in Victoria. In 1963 a large commemorative exhibition of her work was shown at the Georges Gallery, Melbourne.

Her importance was re-established by an exhibition held at the National Gallery of Victoria in 1981.

Girl with Hen, 1956
Brush and ink on paper

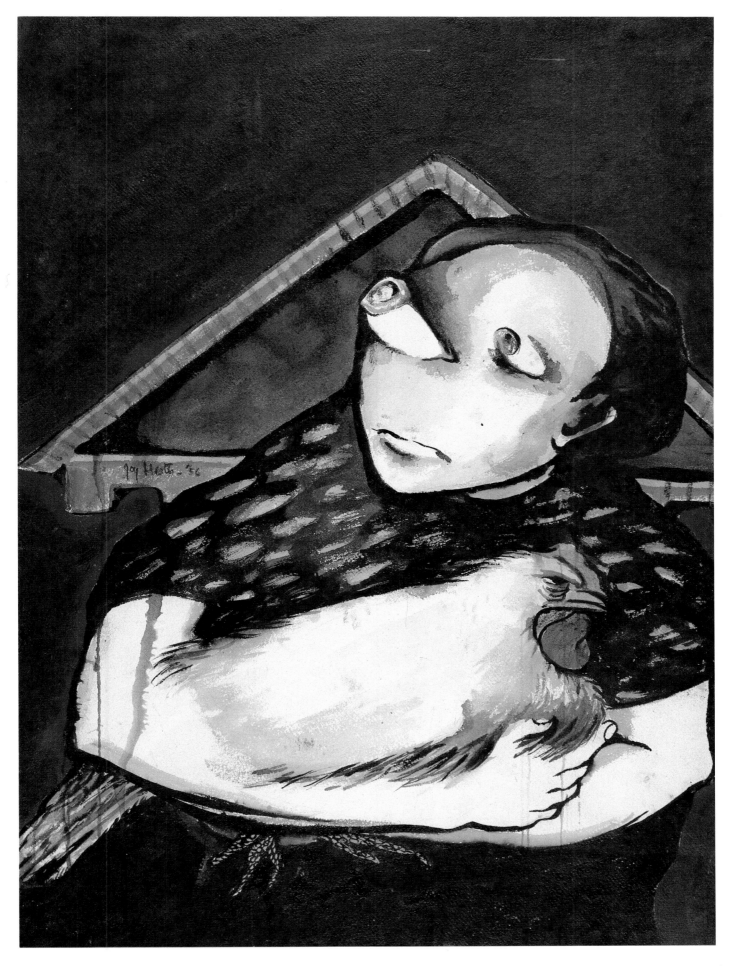

JUDY CASSAB

b. Austria 1920

Born in 1920, this expatriate Hungarian artist arrived in Sydney in 1951 and rapidly established a reputation as a portrait painter of distinction: twice, in 1960 and 1967, she won the Archibald Prize.

The Australian landscape has always been regarded by her as 'exotic' and she usually portrayed it as mystical, almost poetic.

One of her best known landscape paintings, *Orange Circumvision*, is typical of the feelings and moods of this painter.

Apart from the Archibald, Judy Cassab has won many prestigious prizes. She is well represented, mainly through her portraits, in State galleries and in England.

Portrait of Margo Lewers, 1967
Oil on canvas

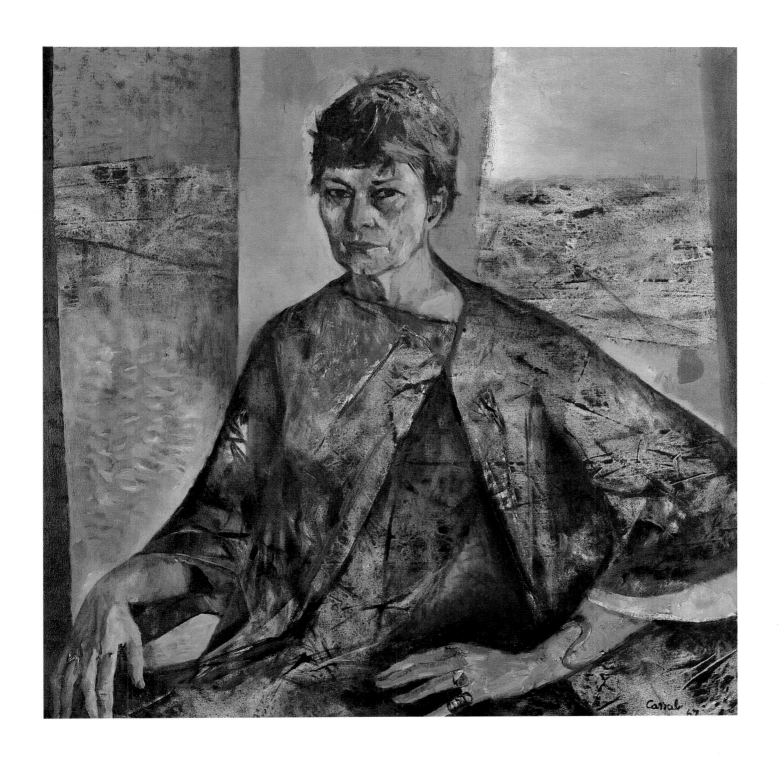

JOHN BRACK

b. Melbourne 1920

This versatile artist has been a painter, draughtsman, teacher, writer and administrator all rolled into one. Born in Melbourne in 1920, he studied at the Melbourne National Gallery School, for a total of 11 years, interrupted by the war years.

Until 1962, he was art master at Melbourne Grammar School, before his appointment as head of the Melbourne National Gallery School. His painting style acquired its early character through Seurat's classic methods of construction and moved towards a style of satirical comment; this later produced his famous series of paintings of which *The Bar* and *Collins Street 5 o'clock* as well as several brilliant portraits of fellow artists were the best examples. Brack's paintings hang in several State galleries; in 1965 he won the Gallaher Prize for portraiture.

Barry Humphries in the character of Mrs Everage, 1969
Oil on canvas

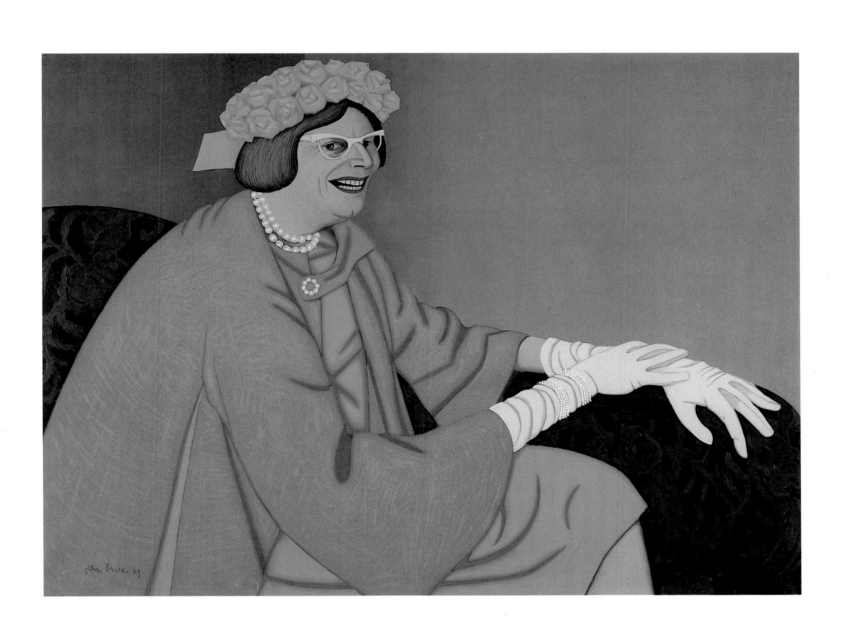

ARTHUR BOYD

b. Victoria 1920

Born into one of Australia's most distinguished artistic families, in 1920, Arthur Boyd's formal education ended at 14 after which he became an assistant to builders and carpenters. In all his spare time, however, the youngster experimented with drawing and painting.

In 1940 he was drafted into the army and would spend most of the war years in a cartographic company at Ballarat. Most of his early paintings had an urban character; Boyd himself described his works from the 1940–45 period as 'imaginary poems' or 'poetic fantasies'. About this time he painted his famous *Hunter Series*, some gloomy landscapes.

In 1951 Boyd travelled to central Australia and, like many other artists before him, 'discovered' the interior. In 1959 Boyd, his wife and three children moved to England.

He came back to Australia for periodic visits and on one of these trips, bought a property at the Shoalhaven River, near Nowra where he was to settle after his expatriate years in England.

Starting in 1950, he won several art prizes. Arthur Boyd's paintings hang in every Australian State gallery and also in many provincial ones as well as the Australian National Gallery in Canberra.

White Cockatoos, Cows and Tent under Pulpit Rock, 1981
Oil on canvas

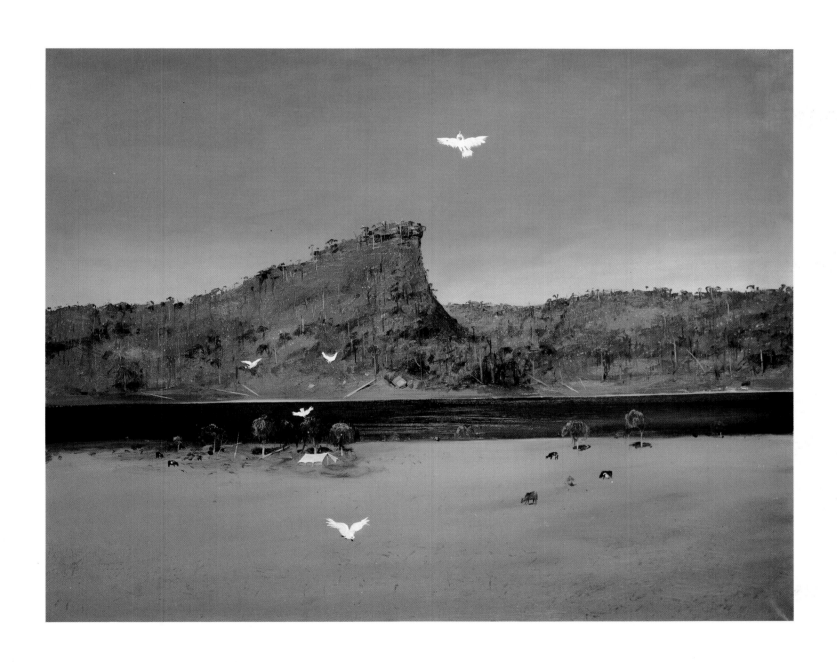

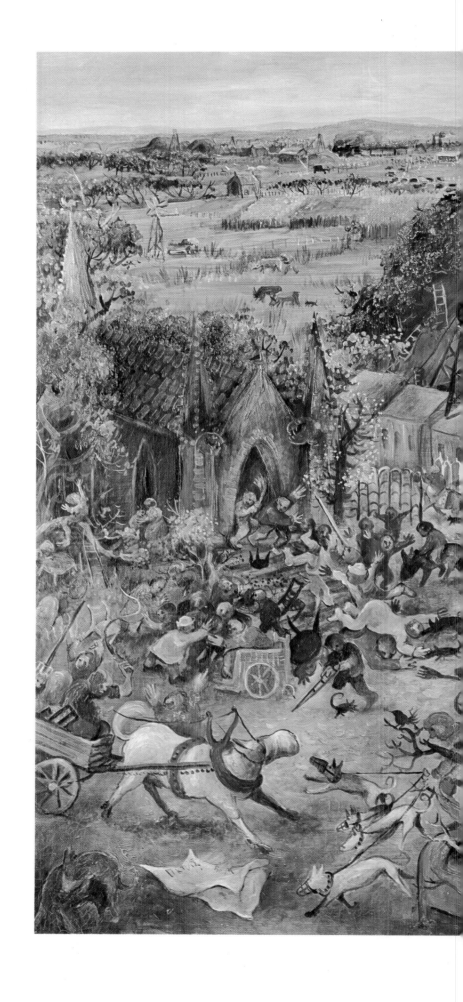

The Mining Town or Casting the Money Lenders from the Temple, 1946–47
Oil and tempera on hardboard

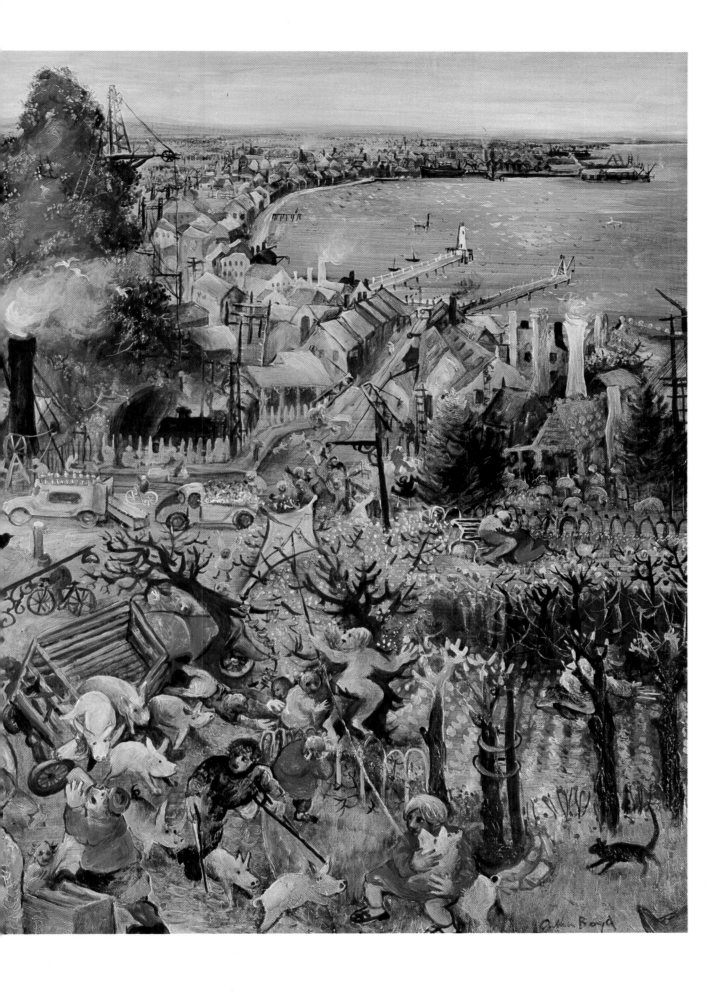

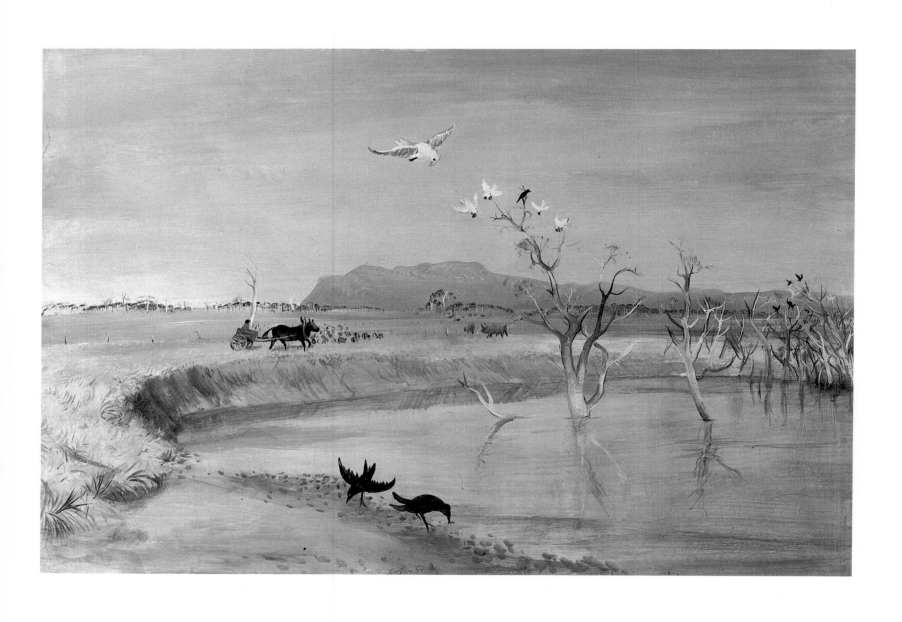

Irrigation Lake, Wimmera, 1949-1950
Resin and tempera on hardboard

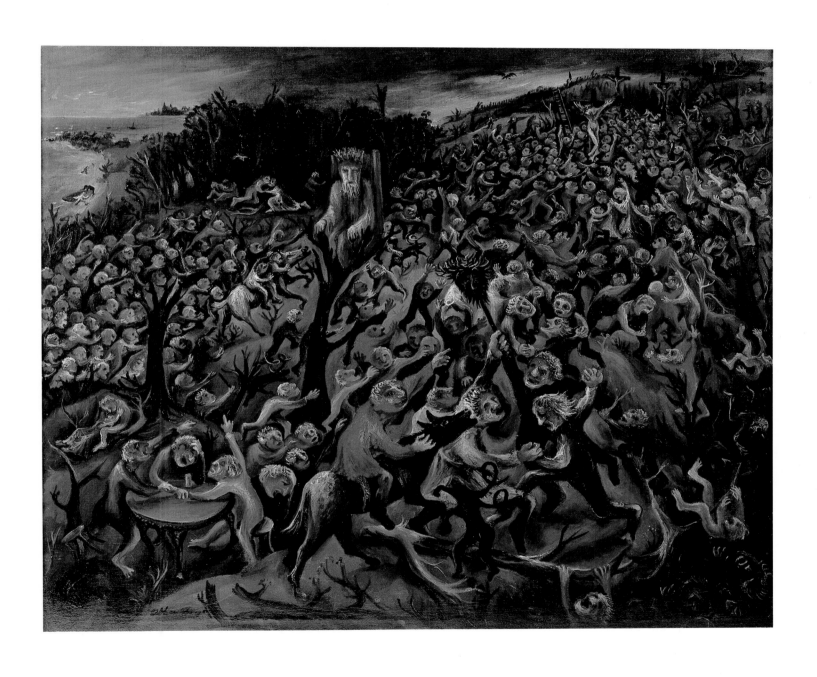

The Mockers, 1945.
Oil on canvas.

JEFFREY SMART

b. Adelaide 1921

Born in Adelaide in 1921, Smart spent a few early years in formal harness: he was a teacher at the South Australian School of Art, Sydney's King's School and East Sydney Technical College, and later became art critic for the Sydney *Daily Telegraph*.

His early studies were in Adelaide and Paris; he studied at the L'Academie de Montmartre and La Grande Chaumiere.

In the early 1960s he went to live in Arezzo, Italy — and is still there, painting.

His landscape paintings are not inventions but discoveries; his most recent works of the Italian scene are clean, clinical, even austere.

Cape Dombey, 1947
Oil on canvas

150

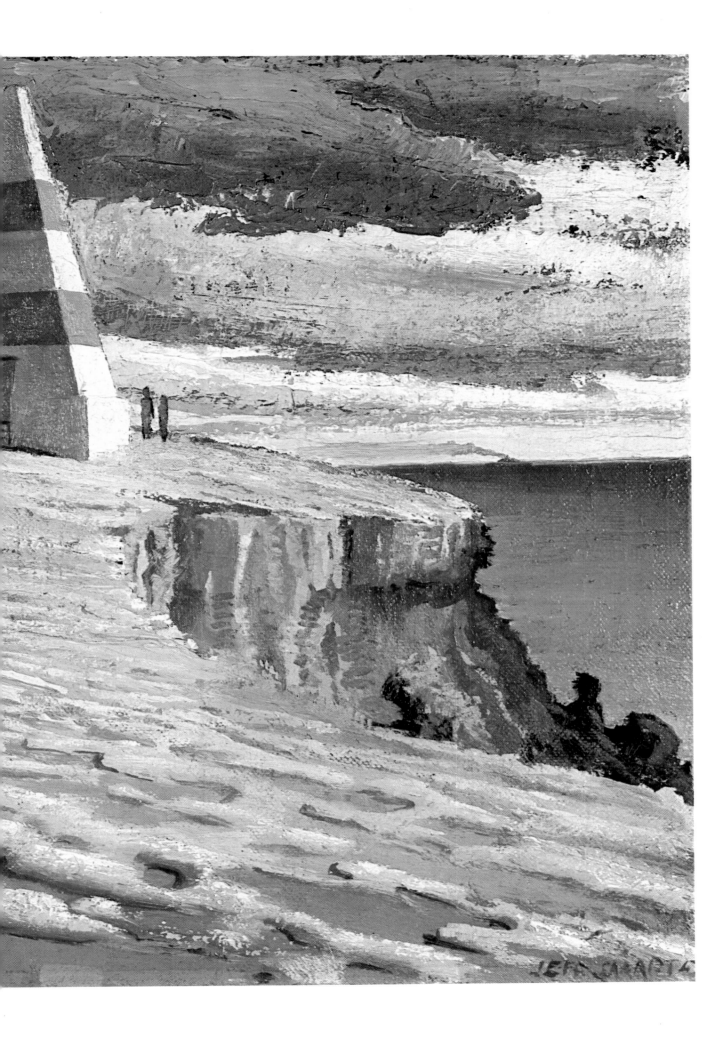

JOHN PERCEVAL

b. Bruce Rock 1923

The painter, potter and ceramic sculptor, John Perceval was born in Bruce Rock, Western Australia and began painting as a boy. During the 1940s he joined a number of artists including Nolan, Tucker and Boyd who were involved with the avant-garde periodical *Angry Penguins* which published a number of Perceval's works.

His early work attracted attention at Contemporary Art Society Exhibitions which demonstrated his talent for surrealist-type pictures. Paintings of this period, such as *Boy and Cat*, reflected the artist's personal anguish.

Between 1949 and 1954 Perceval abandoned painting to concentrate on ceramics. His friendship with his brother-in-law Arthur Boyd resulted in Perceval taking part in the revival of the Boyd family pottery works at Murrumbeena, Victoria. Perceval's ceramic 'angels' exhibited at the Melbourne Museum of Modern Art in 1958 were the culmination of his success as a potter and sculptor.

In the mid 1950s Perceval returned to painting with outstanding landscapes of Victoria's bushland and coastal scenery. In the 1960s he spent three years in London and returned to receive a two-year fellowship at the Australian National University, Canberra.

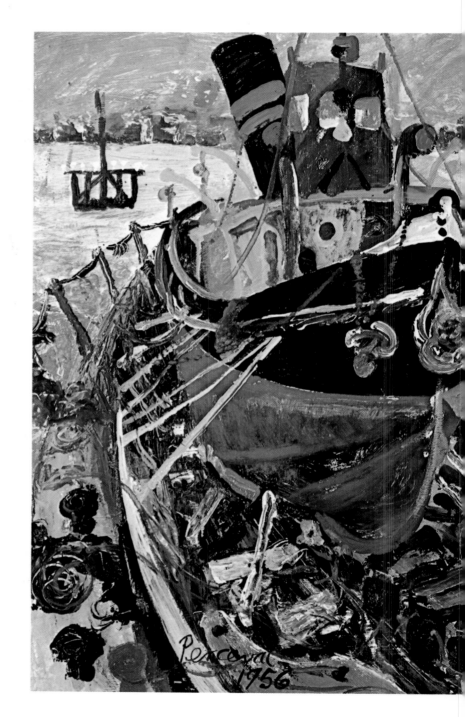

Tugboat in a Boat, 1956
Oil and enamel on hardboard

ROBERT DICKERSON

b. Sydney 1924

His background story reads like a movie script: born (in 1924) at Hurstville, New South Wales, Dickerson left school at 14, worked in factories then spent some years as a professional boxer. Later he joined the RAAF and served on the ground staff during the war. He began to paint seriously in 1950, at 26, and first became known through his exhibitions in Melbourne and Sydney. His monumentally conceived, two-dimensional figures were later followed by a regular output of large charcoal drawings. He started to win prizes in 1954.

Street Corner, 1953
Oil on hardboard

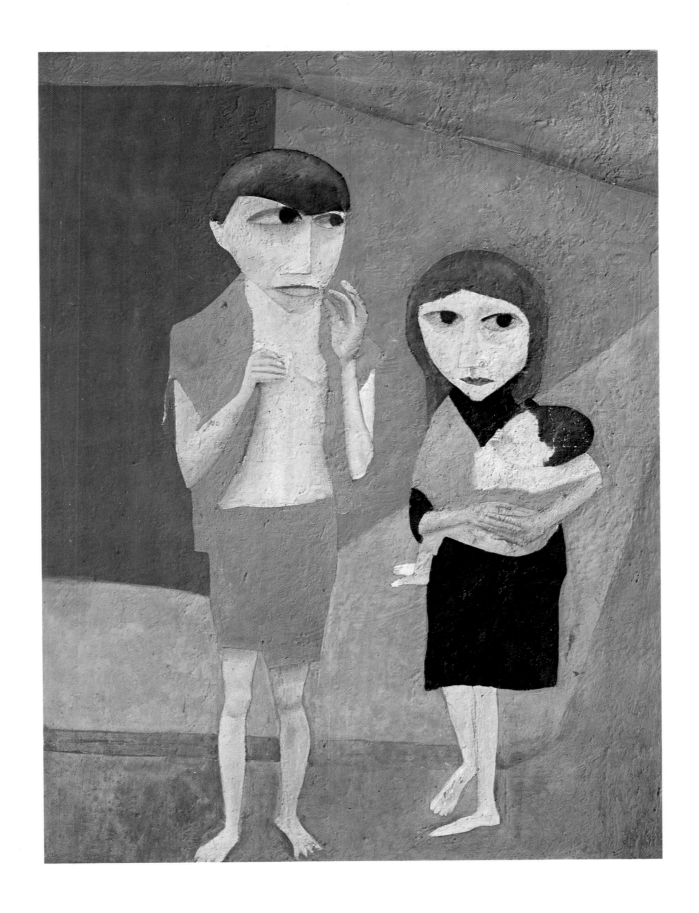

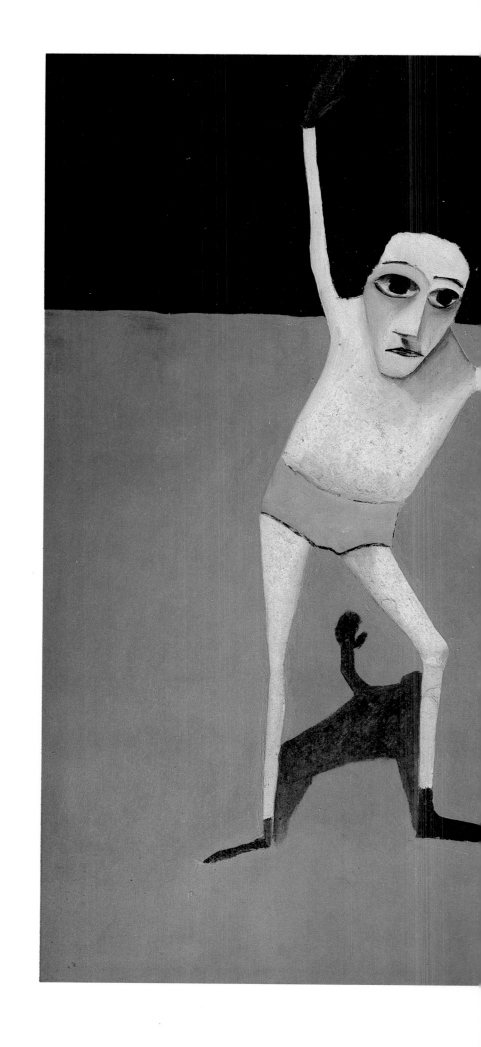

K.O.'d by Griffo, 1953
Enamel on composition board

156

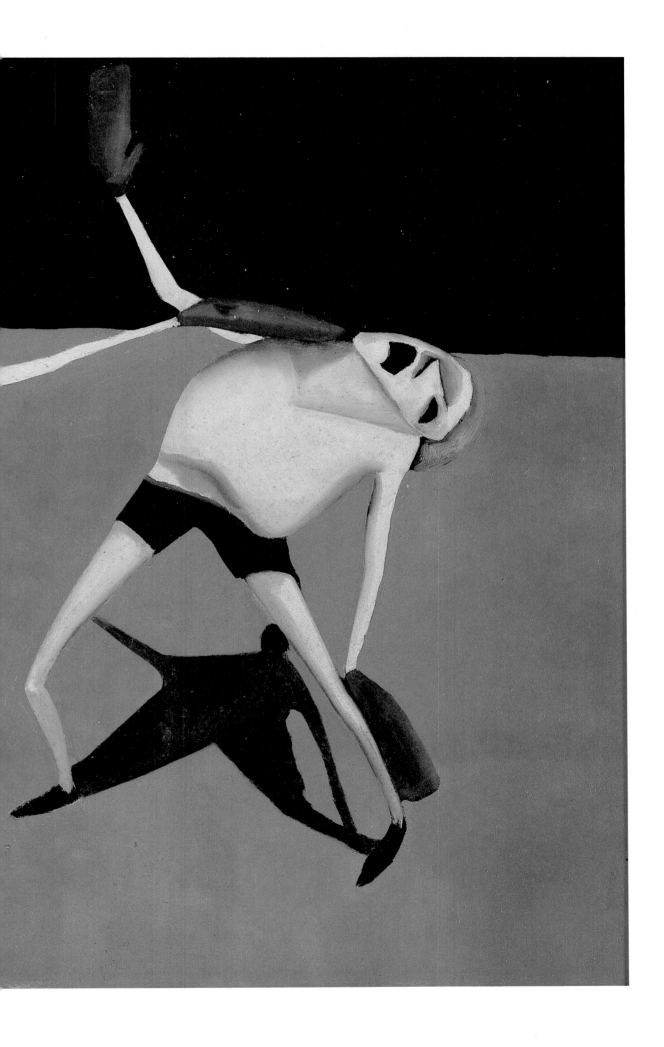

JOHN COBURN

b. Ingham 1925

A painter, teacher and designer of large-scale tapestries, John Coburn was born in Ingham, Queensland, in 1925. He studied painting at East Sydney Technical College, receiving a diploma in 1950.

Coburn worked as a graphic designer for ABC television from 1956 to 1959. He held his first one-man exhibition in Sydney and Melbourne, then taught art, while continuing to paint, in Sydney and Canberra.

Moving to France in 1969, Coburn there received a commission to design the well-known tapestry curtains which decorate the interior of the Sydney Opera House. The curtains were woven at Aubusson, France, where they took three years to complete at a cost of $100,000. On returning to Australia, Coburn became head of the National Art School in Sydney.

Coburn's paintings and tapestries generally utilise simple interlocking shapes to form abstract designs. His work is represented in all State galleries, the Australian National Gallery, Canberra, and the Vatican Museum, Rome. Coburn has twice won the Blake Prize.

Primordial Garden, c. 1965-66
Liquitex on hardboard, three panels

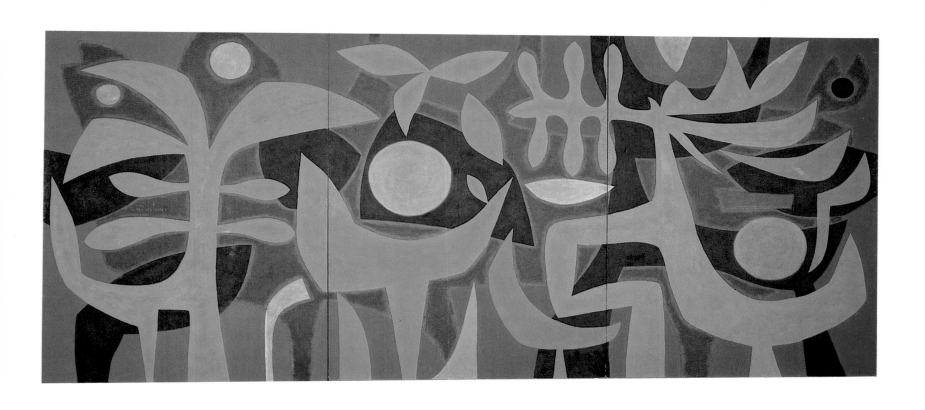

Nullabor, 1980
Oil on canvas

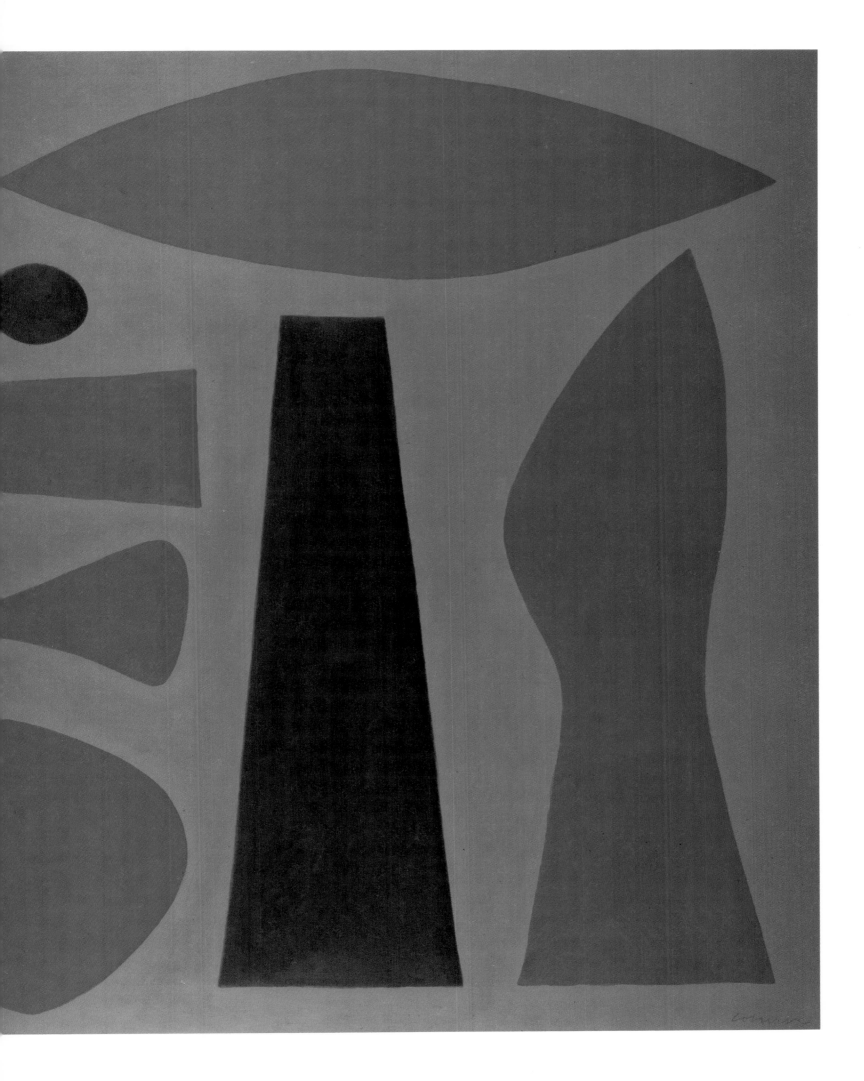

FRED WILLIAMS

b. Melbourne 1927; d. Melbourne 1982

Superb versatility was the main characteristic of Fred Williams.

He was born in 1927 in Melbourne and his parents planned a career in architecture for their son. However, the young boy was drawn to art and soon enrolled at the Gallery School for formal studies.

His lifelong commitment came in 1951 when he travelled to London and began a four-year study at the Chelsea Art School. Later he also studied at the Central School of Arts and Crafts.

During this period he perfected his technique of drawings and etchings though he also continued to paint and sketch landscapes. He came under the strong influence of Matisse — his painting, *Chiswick* is a good example of the French master's influence.

While studying in England, he did a number of brilliant sketches of London characters; mainly ordinary people, music hall artists, circus acrobats and even dwarfs. More than the other expatriate Australian painters, like Dobell, Williams dealt mainly with London life rather than London scenes, avoiding the exotic and anxious to portray the everyday life.

He returned to Australia in early 1957 as a fully-fledged artist and almost immediately held two one-man exhibitions. For the next five years he was in demand by galleries in Sydney and Melbourne and became firmly established as one of the best Australian painters. He was included in some important Australian exhibitions to tour overseas and began to win several awards and prizes.

By 1963, Williams was recognised as a major Australian painter; he had the famous *You Yang* and *Upwey* landscape series behind him, both of which created a generous amount of controversy.

In his prime, Williams went to Europe in 1964 on a scholarship, spending seven months visiting galleries and exhibitions. He also returned occasionally to figure subjects, making a number of splendid etchings and drawings.

In the 1970s Williams spent long periods in Queensland painting landscapes and a 1975 trip resulted in the excellent *China Sketchbook*, giving images and impressions. The same year a rare honour befell him: he became the first Australian painter to be invited to hold a one-man exhibition at the world famous Museum of Modern Art, New York.

To again prove his immense versatility, in 1976-79 Williams produced a series of major portraits in oil, some of which were entered in the Archibald Prize. Although he didn't win this, his entries received rave notices from critics.

One of his last major undertakings was the Pilbara series, the result of extensive travel in this rugged area.

In November 1981 he was taken seriously ill and, within six months, at the age of 55, he died.

Soon after, in 1982, when the Australian National Gallery opened to the public, the section accommodating Australian art was named The Fred Williams Galleries.

Cricketer, 1955
Oil on board

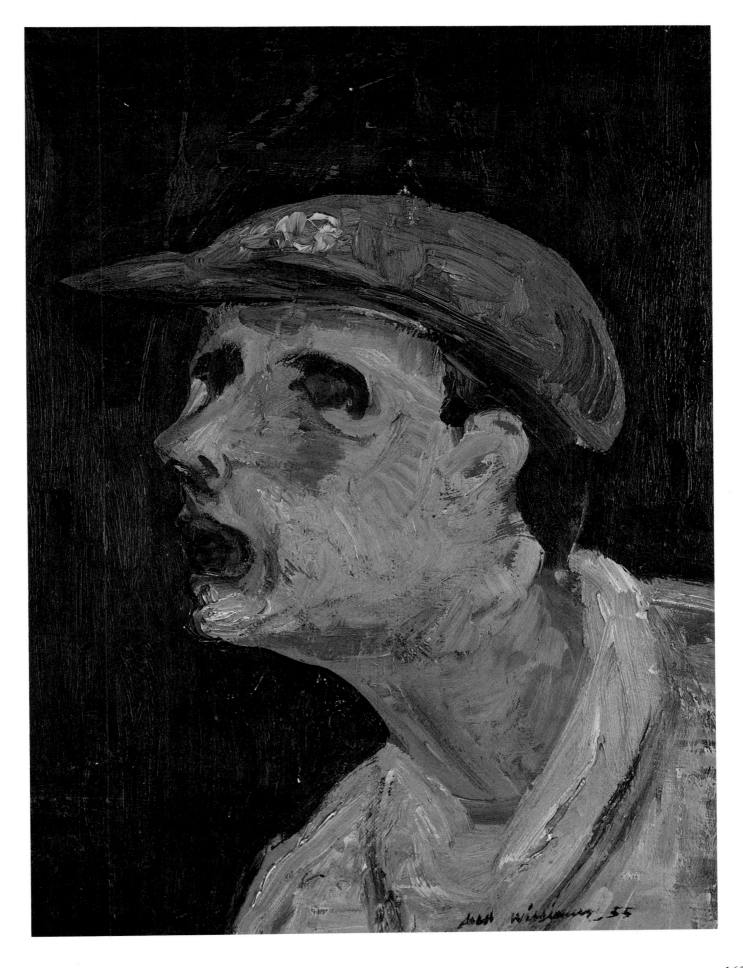

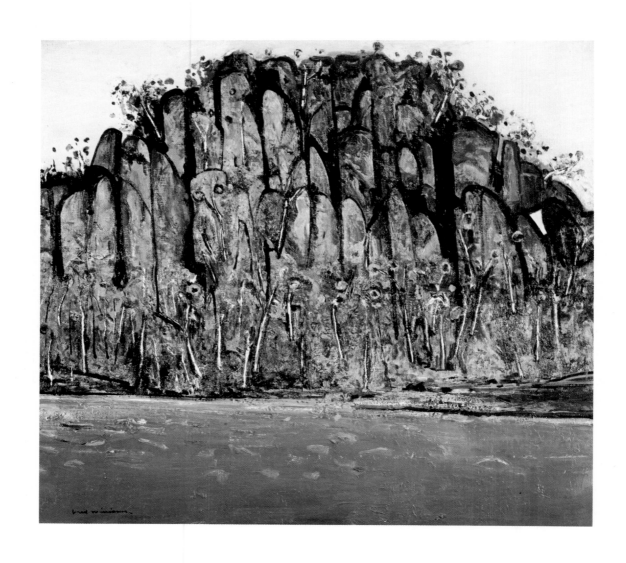

Hanging Rock, 1976.
Oil on canvas.

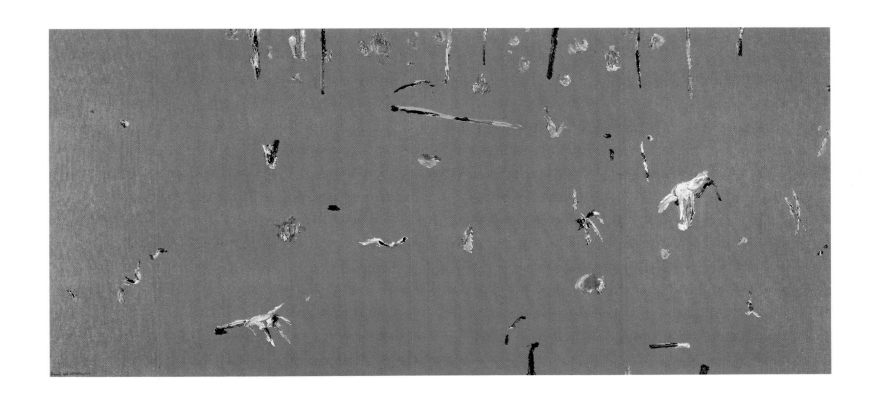

Landscape, 1969.
Oil on canvas.

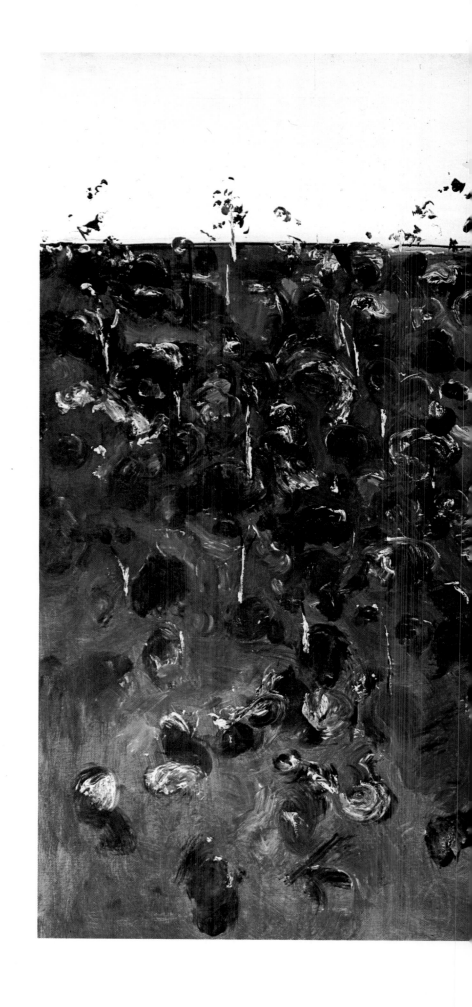

Upwey Landscape, 1965
Oil on canvas

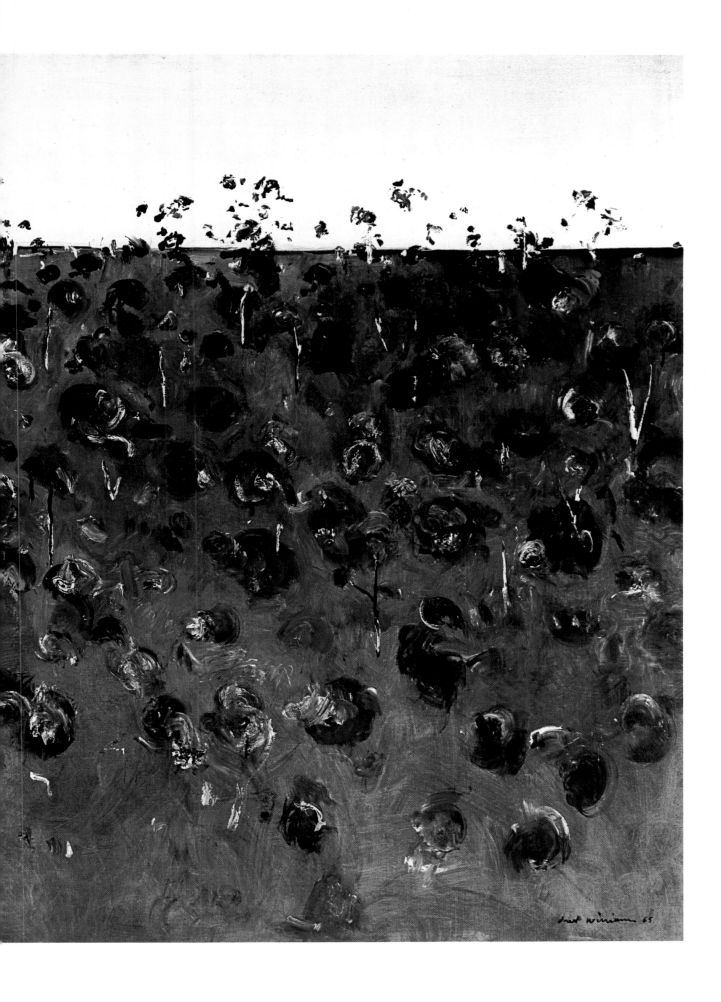

JOHN OLSEN

b. Newcastle 1928

An abstract artist with a lively, uninhibited style, John Olsen is probably best known for his mural in the northern foyer of the Sydney Opera House — a work which is based on Kenneth Slessor's poem *Five Bells*.

Born in Newcastle, New South Wales, Olsen studied at the Julian Ashton and Dattilo Rubbo art schools. His early paintings were semi-abstract works in the style of the French artist Cézanne. In the early 1950s his work was shown in three exhibitions, but it was in 1955–56 that he gained his first public success in Melbourne when a small painting was bought for the National Gallery of Victoria.

In 1956 Olsen exhibited a series of paintings which attempt to evoke sensations and experiences associated with Sydney ports. Travelling to Europe later that year, he remained overseas (living mainly in Majorca) until 1960. In Paris he exhibited with several prominent French abstractionists. On his return to Sydney in 1960 Olsen executed a series of pictures titled *You Beaut Country*: these paintings reflected his ideas on the impact of environment, as well as his deep affection for Sydney and its environs. In 1964 Olsen went to Portugal to supervise the production of tapestries he had designed. While overseas, he also travelled to and lived in Spain, Mexico and New York, returning to Sydney in 1967.

Olsen has exhibited throughout Australia and in many other countries. He has won several prizes including the Wynne Prize (1970) and was appointed OBE in 1977. Olsen co-authored the book *The Artist and the Desert* (1981) with Sandra McGrath.

Lake Eyre, 1975
Oil on canvas

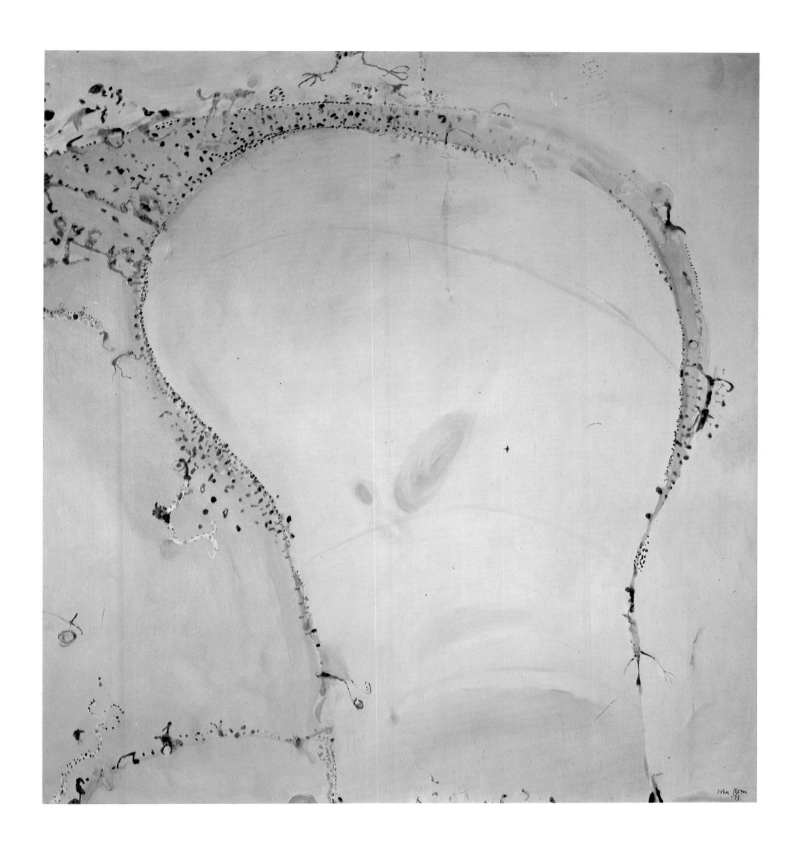

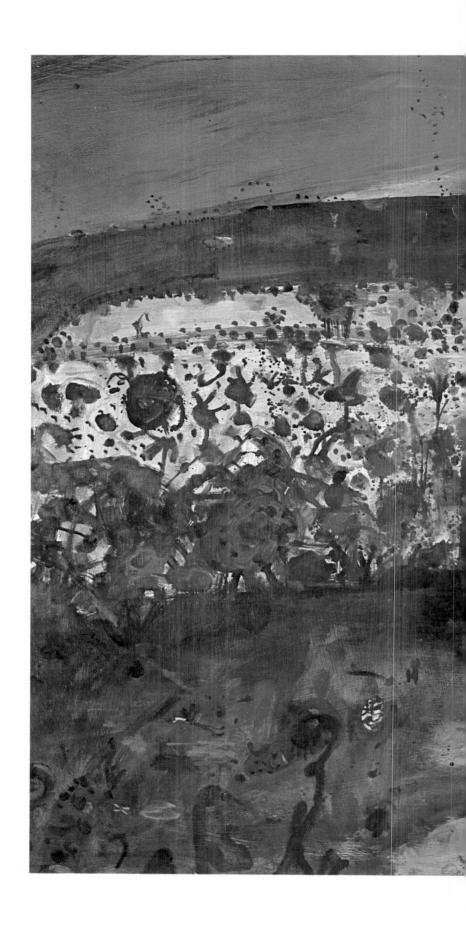

Fogg Dam, 1974
Oil on cardboard

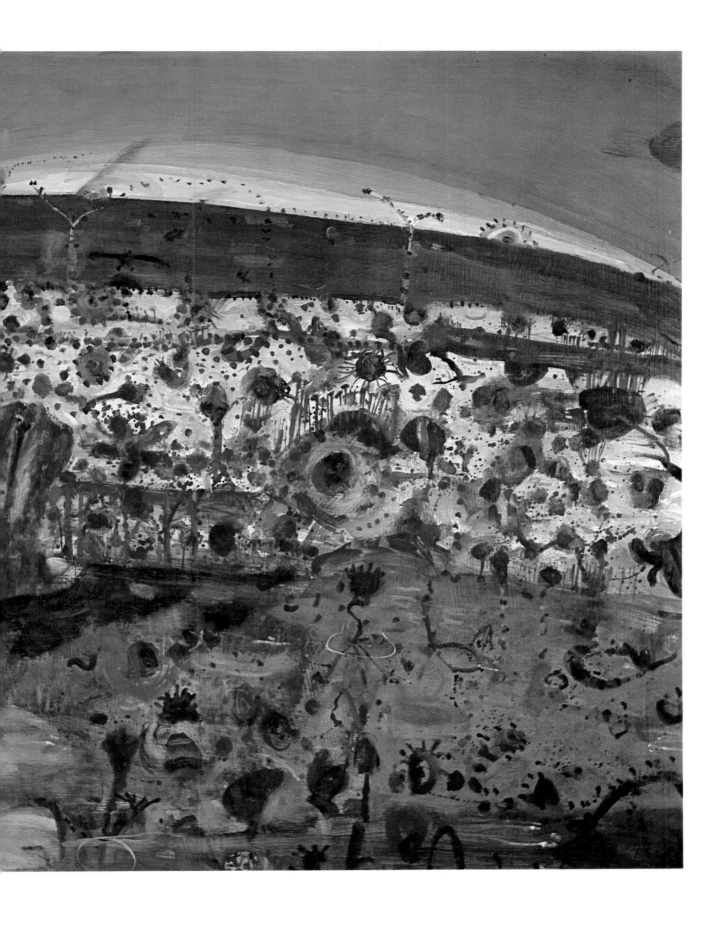

CHARLES BLACKMAN

b. Sydney 1928

A painter known mainly for his figure studies, Blackman's work tends to feature women —
often depicted as sad, detached figures, but painted in bright colours. Born in Sydney in
1928, Blackman studied drawing at the East Sydney Technical College. He worked as an
artist for Sydney's *Sun* newspaper for five years, before settling in Melbourne in 1952. His
first one-man exhibition in 1953 created press controversy when some of his paintings and
drawings, particularly *The Swimmer,* became the centre of a debate on modern art.

In Melbourne Blackman helped to re-establish the Contemporary Art Society. His major
series of paintings, based on the story of *Alice in Wonderland,* was completed in 1957.
Blackman did not, however, receive official recognition until 1958, when the Paris Museum
accepted one of his paintings. His reputation was further strengthened when he was
awarded the Rowney prize for drawing in 1959 and soon afterwards held a successful
exhibition in Brisbane; he also received a travelling scholarship in 1960.

After travelling in England and Europe, Blackman settled in Australia again in 1966. He
is represented in most major Australian and many overseas galleries.

Girl in the Checkered Dress, 1963
Oil on canvas mounted on board in two panels

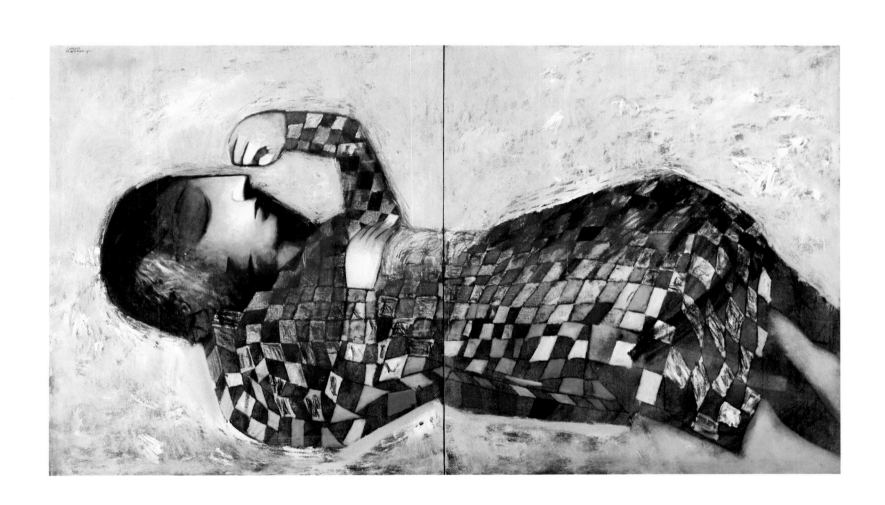

LEONARD FRENCH

b. Brunswick 1928

Noted for his large-scale artworks, Leonard French works in a variety of media including stained glass, mosaics, tapestry and paint.

Born and educated in Brunswick, Victoria, French trained as a signwriter and studied art part-time at the Royal Melbourne Technical College. He painted his first mural in a local church when he was 19. In 1949 he travelled to Europe, studying and painting there for about two years.

Returning to Melbourne, French worked as a teacher and continued to paint. He exhibited his *Iliad* pictures in 1952, followed in 1955 by a larger exhibition of the *Odyssey* series. Soon afterwards French painted several murals for the 1956 Melbourne Olympics and completed a monumental mural for the Beaurepaire Physical Education Centre at the University of Melbourne. He was exhibition officer at the National Gallery of Victoria from 1956 to 1960.

In 1961 French became a full-time artist and this marked an important phase in his creativity: he produced a series of five paintings known as *Genesis* in 1961 and the twenty-part *Campion* series of murals in 1962, both of which won acclaim. The *Seven Days of Creation* series followed. In 1963 he completed a stained-glass ceiling for the Great Hall of the National Gallery of Victoria. Since then French has completed several windows, including one at the National Library, Canberra.

French has won many Australian art prizes, as well as a Harkness Fellowship to the United States which he received in 1965. He was appointed OBE in 1969, and became one of the few Australians represented in the Museum of Modern Art, New York.

The Burial, 1960
Enamels on hessian covered hardboard

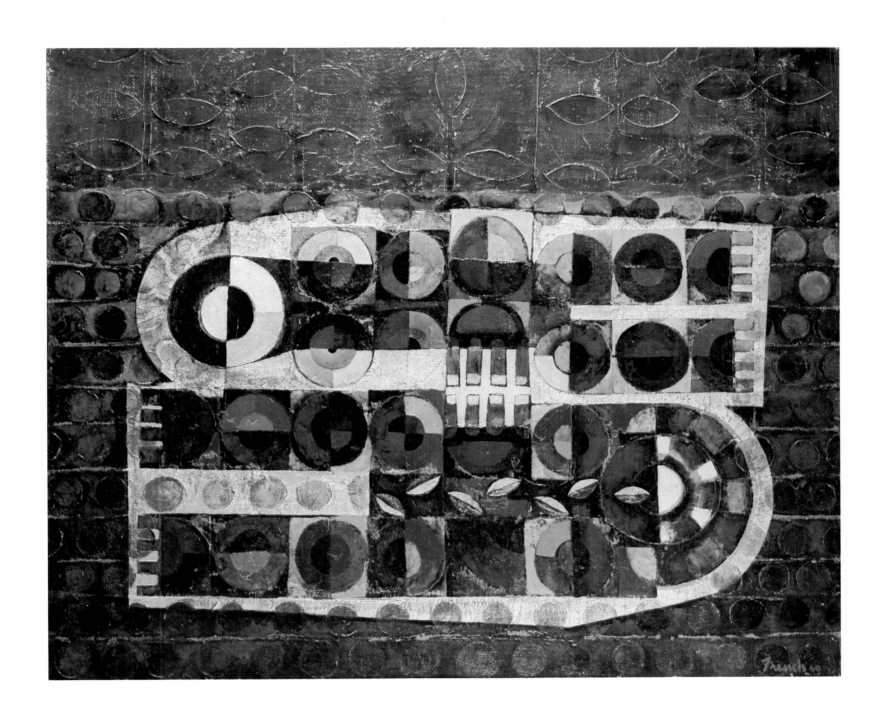

BRETT WHITELEY

b. Sydney 1939

The highly successful painter Brett Whiteley is well-known for his dynamic, often large, canvasses — particularly his portraits, fragmented nudes and still life paintings often depicting ceramic pieces designed by Whiteley himself. Many of his paintings utilise a colour range of black, white, ochre and pink.

Whiteley was born in Sydney in 1939, and educated at Scots School, Bathurst, New South Wales and Scots College, Sydney. While working as an advertising artist, he studied at the Julian Ashton Art School. In 1960 he was selected by Russell Drysdale as the winner of an Italian Travelling Scholarship. After spending a year in Italy, another award, the Paris Bienniale Prix International, enabled him to study in France. He remained overseas until 1969, living mainly in London where he established a reputation through numerous exhibitions. The Tate Gallery's purchase of his *Untitled Red* made Whiteley the youngest ever painter to be exhibited in this internationally revered gallery. In 1967 he went to the United States on a Harkness Foundation Scholarship and worked in New York for over a year.

Since returning to Sydney in 1969, Whiteley has produced many works which received great critical acclaim: these include *Alchemy* (1971), a series on the theme of 'waves' in 1973 and the Lavender Bay series which culminated in *The Jacaranda Tree* (1977). The latter painting was awarded the Wynne Prize of that year and was sold at an auction in 1982 for A$115 000, then a record price for an Australian painting. It was in 1977–78 that Whiteley received probably his greatest honour: he became the first artist to be awarded the Archibald, Wynne and Sulman prizes in one year.

Self Portrait in the Studio, 1976
Oil and collage

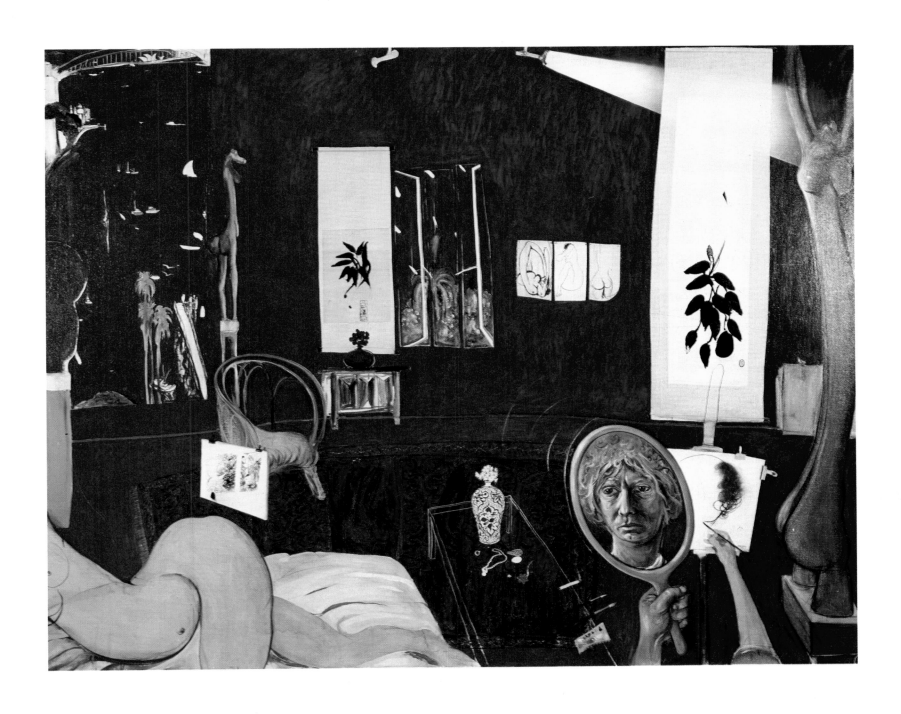

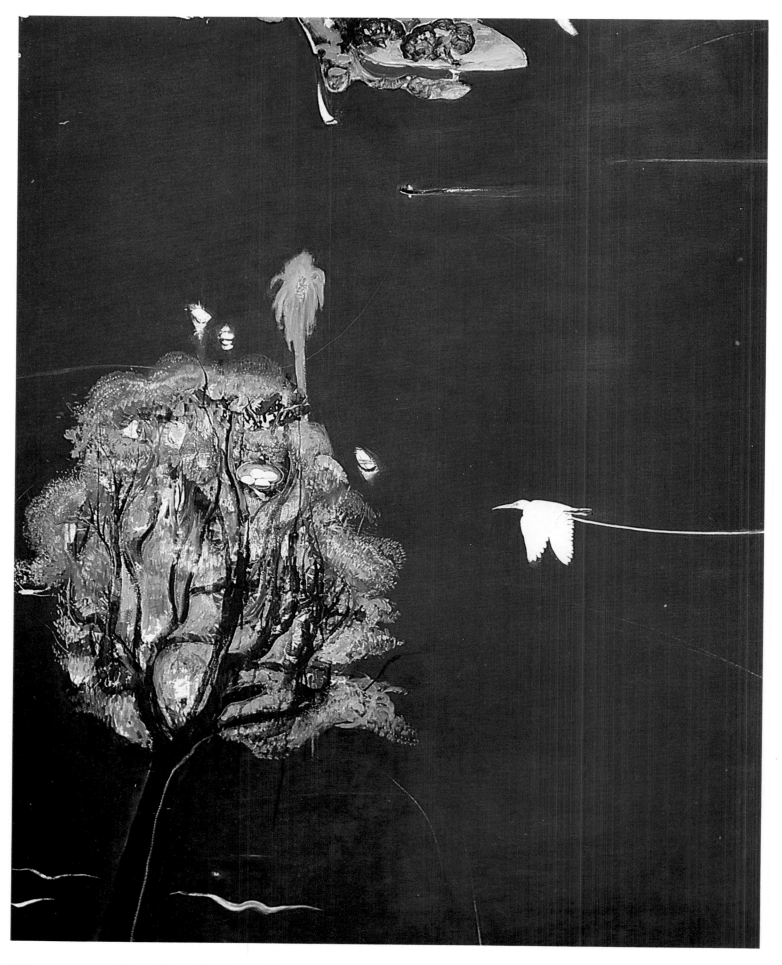

178 Detail from *The Jacaranda Tree (on Sydney Harbour)*, 1977. Oil on canvas, centre panel.

179

The Pond at Bundanoon, 1976. Oil on canvas.

The Cricket Match, 1964
Oil on canvas

INDEX

List of Plates and Acknowledgements:—
The publisher wishes to thank the artists and the institutions and private collectors who have kindly given permission for their works to be reproduced.